W9-AIA-239

THE LIBRARY OF GRAPHIC NOVELISTS™

BRYAN TALBOT

LITA SORENSEN

The Rosen Publishing Group, Inc., New York

For my mother, Loretta, and sisters, Toni and Patra

Published in 2005 by The Rosen Publishing Group, Inc.
29 East 21st Street, New York, NY 10010

Copyright © 2005 by The Rosen Publishing Group, Inc.

First Edition

Library of Congress Cataloging-in-Publication Data

Sorensen, Lita.
Bryan Talbot / by Lita Sorensen.
 p. cm. — (The library of graphic novelists)
Includes bibliographical references and index.
ISBN 1-4042-0282-X (library binding)
1. Talbot, Bryan. 2. Novelists, English—20th century—Biography.
3. Graphic novels—History and criticism. 4. Artists—Great Britain—
Biography. 5. Graphic novels—Authorship.
I. Title. II. Series.
PR6070.A356Z88 2004
823'.914—dc22

2004011071

Manufactured in Malaysia

CONTENTS

ost people think of comic books as cheap, colorful, throwaway entertainment for children. They have never been regarded as sophisticated reading material. But since the mid-1970s, the comic book genre has undergone a revolution of sorts, and today many of its readers are in their teens, twenties, and beyond.

In his book, *Comic Book Culture*, Matthew J. Pustz, adjunct professor of American studies at the University of Iowa, tells a story that will be familiar to many comics fans:

> For a number of years, I did not tell anyone I read comic books. Whether this was the fault of the comic books or my own insecurities, I am not sure, but during my four years as an undergraduate, I kept my comic-book-reading past a secret from my classmates. Sometimes, I would sneak off to a

Bryan Talbot has been creating comics for over thirty years. He has had a tremendous impact on the comics genre in his native England and in the United States, and his readership extends to fans around the globe. Here he signs copies of his work for fans at a comics convention.

bookstore near campus to check out what was happening in the latest issue of Avengers or Justice League but I did so only when I knew no one would see me. "It's time to be an adult," I must have thought to myself, ashamed of my continuing need to look at the latest issues. "It's time to get rid of this nasty habit."

And so he sold most of the comic books he'd accumulated over the course of twelve years, storing the rest in the recesses of a closet.

Pustz relates that up until this time, comic books had been a central part of his life, and that by the time he was in junior high school, he had become a very discerning comic-book reader, taking the titles and authors very seriously. He created a world of his own, role-playing with action figures and creating elaborate plots and themes. He wrote fan letters to comic-book authors, and for a time, considered becoming a comic-book writer himself.

What is it about comic books that grabs the imagination of a young child and refuses to let go? Perhaps it is the pages and pages of well-executed and underrated artwork, often in brilliant color, impressive detail, and active compositions. Perhaps it is the narrative web of the stories, or the appeal of the characters. Certainly, it is a combination of all these things that makes the comic medium special and separates it from other forms of media. In this sense, it is not difficult to imagine formulating one's own world around comic books, just as it is not difficult to understand some kids building their lives

around sports, movies, or whatever sparks their imagination and passion.

Matthew Pustz decided he needed to grow up and stop his comic-book obsession. A few years later, he re-entered the world of comics, when, as a graduate student, he first started researching the comics culture and its place in American popular culture. He took a course in which he interviewed a local comic-book writer and artist. He told himself he needed to familiarize himself with the world of comics, bringing him back full circle into the life he had known as a child. Now, as a scholar, Pustz writes about fan culture and admits that he most likely owns more comic books than he did when he was a kid.

Comics, especially the longer, book-length versions called graphic novels, are serious stuff. They boast a culture all their own, with a readership that prides itself on being far from the mainstream. In addition, the comics industry has proven that it is capable of influencing other mass industries, such as the movie business: the popular films *Spider-Man* (2002) and *X-Men* (2000), for example, were both based on comic books and were tremendous successes. Today's comics are a showcase for some extremely creative, talented artists and writers that many people outside the culture have likely not heard of.

One such author is the British comic-book artist and storyteller Bryan Talbot. On his official Web site, Talbot identifies himself as one who "works in the comics medium," hinting at the common notion that comic-book artists and writers are not recognized as serious writers

and artists. To the contrary, Talbot's work includes excellent artwork in conjunction with well-crafted stories.

Besides having a serious comic-book fan base, Talbot's work has been recognized by the likes of the *New York Times,* the British Library awards, and at serious literature festivals. His graphic novel, *The Tale of One Bad Rat* (1995), a moving and groundbreaking story about a young girl who is the victim of child sexual abuse, won multiple awards and honors, and is on the reading lists of several schools and universities. It also is being used by child abuse centers as a reference in the United States, England, Finland, France, and Germany. Recently, Fat Dragon Productions, a film production company headed by popular comic-book artist Tom Lyle and his wife and partner, Susan Paris Lyle, acquired the rights to *The Tale of One Bad Rat* for development as a feature-length movie.

The novel, which Talbot illustrated and wrote, is not what most people expect a comic book to be. There are no superheroes. There are no space aliens or women drawn as bombshells. There is no plot against the world and no method to save it. But, as Talbot said in an interview at the Durham Literature Festival in England, "This has been the most worthwhile book that I have been involved with and the best comic work that I've ever done, not to mention the hardest work."

Talbot has been quietly creating some groundbreaking illustrations and stories in the form of comic books for more than twenty years now, beginning with *The Adventures of Luther Arkwright* (1978), which became a classic and was serialized in several British titles over

a period of ten years and then repackaged into a novel. Like the more recent *One Bad Rat*, *Luther Arkwright* won numerous awards. Most recently, Talbot's new graphic novel, *Heart of Empire* (1999), has been published in its entirety, and a CD-ROM of the novel has just been released.

There is a great diversity within any given comic-book culture. Fans and readers, professionals working within the business (who likely started as fans), and the writers and artists working within the genre all contribute to an active, vibrant culture. Bryan Talbot's work has added a great deal to this vibrant culture. A true artist and an original creator, he is one of the comic world's most respected artists and writers. And although the graphic novel has not yet truly reached mainstream popularity as an art or literary form, Talbot's *One Bad Rat*, with its exploration of a real-life problem and its universal theme of self-renewal, has come close.

The *Tale of One Bad Rat* is just one example of Talbot's contributions to the comics medium. The body of work he has produced thus far in his life has had a tremendous impact on the history of the graphic novel.

A HISTORY OF COMICS

The history of the graphic novel stretches further back than most people would think. Much further back, certainly, than the mid-1980s, when graphic novels began to enjoy attention and popularity. The evolution of the form can be traced back on a long, winding path to the nineteenth century.

According to Roger Sabin, in his book *Adult Comics: An Introduction*, the very first comics that actually fit the definition of what we consider to be a comic strip today appeared in Great Britain near the end of the 1800s industrial period. They were printed to be sold for quick profit and were considered cheap, simple entertainment for the working classes. To maximize their earning potential, comics were geared toward children and teens and also adult audiences, specifically male clerks and shop workers.

The deeper history of comics is not clear. It is believed that it slowly evolved from other forms of visual communications. Some experts trace comics back to ancient times, to Egyptian hieroglyphics or even to the Paleolithic cave paintings of pictographs that have been uncovered. Another theory traces the beginning of comic books and graphic novels back to illustrated children's books, and also to the cheap pulp novels that started in Victorian England (a period of English history roughly from the late nineteenth to early twentieth centuries).

Above all, it is known that the very first comics were meant to be funny. Therefore, they can be best placed within the genre of satire, a humor form that uses irony and sarcasm to expose ridiculous actions and make fun of a person, usually a public figure or politician. Illustrated comic magazines, prints, and posters of the day expressed a sense of humor that is very similar to the humor of today. They also show us the beginnings of distinctive comic-book features such as speech balloons, captions, and panels.

Technology and the advent of advanced printing techniques played a large part in the development, distribution, circulation, and popularity of satirical works. Comic prints, or broadsheets, were produced by an artist etching a cartoon or caricature into a copper plate. This method later gave way to lithography, which made it possible to produce multiple copies without reducing the quality of the reproduction. Therefore, many quality copies of a work could be distributed to the masses for a cheap price.

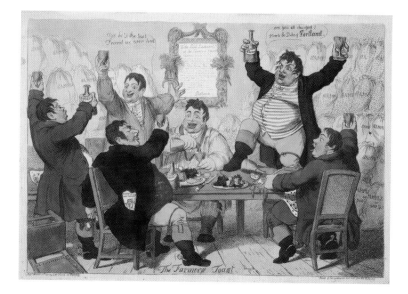

This British political cartoon was intended to satirize monopolists in nineteenth-century England. Published in 1801, "The Farmers Toast" has six well-fed farmers feasting while they hoard their valuable supply of corn in hopes of obtaining higher wages for it from the government.

As the funny lithograph satires became more common, so too did the colloquial term "comicals," which was further shortened down to just "comics." British humorists of the day attacked and satirized the wealthy with images of grinding poverty and also took the fine art of caricature to a new level, producing outrageous images of public figures of the day.

Audiences for comics were divided into two different types. Traditional high-quality single prints, sometimes done in color, were intended for a wealthier, educated, middle-class readership who was well-acquainted with the politics and social issues of the day. In addition to these finer quality images, however, were cheaper prints and broadsheets produced with larger print runs and done with cheaper materials aimed at a larger cross

KID COMICS

From about 1905 onward, the comics business went through a remarkable change. Although many comic-book publishers had always counted on having children as their readers, publications offered only small "children's corners" within comic publications that were intended for adults. Soon, it became obvious that the comics for kids were the most popular and attracted the most profits. Eventually, children made up most of the readership.

Publishers figured out that as long as they kept the price of a comic low, within the range of a typical kid's pocket money, producing work for this market might increase profits. To attract children's attention, slapstick comedy was added, and publishers began to experiment with color in earnest. Satirical humor was reduced, as was the amount of text within the comics. This alienated the adult audience, who associated color illustrations and sparse text with children's books.

By 1914, the vast majority of comics was aimed at the eight-to-twelve-year-old age range. Some remnants of the old comics remained, and production on a few of the more sophisticated satirical strips continued, but the typical audience for the industry changed to kids and stayed that way.

section of the population. These were more silly than satirical; their cost was also much less expensive, sometimes retailing at a penny per sheet. Remarkably, circulation for this kind of broadsheet publication was often up to 100,000 for a very popular comic.

The Comics Industry

By the second decade of the 1800s, something of a comic industry was already beginning to establish itself. It employed hundreds of artists, cartoonists, and caricaturists, most of whom produced their work for very little money and lived in obscurity without recognition. These artists traditionally obtained a social status somewhat on the same level as sign painters. They were not admitted membership to any of the artist academies and they did not exhibit their work, as the work of cartoonists and comic sketch artists was never considered serious or a true art like painting or drawing.

One monthly humor magazine, *Punch*, founded in 1841, and named after the famous puppet from *Punch and Judy* shows, developed a gentler, less satirical comic tone, featuring a mix of funny stories and cartoons (the true forerunners of today's newspaper comic strips). Many very talented humorists and brilliant cartoon artists were featured within its pages, until its official demise in 1992. Although their work was often outstanding, it was still paid very little respect. One well-known cartoonist related in Sabin's *Adult Comics* that, "I would rather be the painter of one really good picture than the producer of any number of 'the kind of things' [I do]."

Published largely for the middle class, *Punch* was commercially successful, and by the mid-1800s, other publishers had decided that a similar magazine might appeal to the lower, working classes. In 1870, England introduced the Education Act, which called for elementary education for all citizens, so the literacy level among the British at this time was fairly high. Other, less sophisticated versions of *Punch* began to surface, such as *Judy*, *Funny Folk*, and *Fun*. Like publications before them, these working-class versions tended to be cheaper and more inclined toward slapstick humor. Cheap paper was often used, and comic themes and strips were sometimes stolen from foreign publications, reducing the rate of pay for the local talent pool of working artists and humorists to extremely low levels.

Historians have noted that circa the 1870s, the British lower classes started to change, resulting in a new kind of culture that found expression in pubs and music halls. Hereafter, the tendency was to accept the class divisions that were so apparent in British society as a natural order. A comic publication, *Ally Sloper's Half Holiday* (1884–1916), was the first to capitalize on this new political mood and make a joke out of it. *Sloper* is widely known as the first modern comic. Like other working-class comic publications, it contained cartoons, strips, and funny stories. What made it different from all the rest, and any of its predecessors, was that it contained a recurring character by the name of Ally Sloper.

Ally Sloper was a scheming, drinking, bulb-nosed, skinny-legged bum and con man who was constantly

GREAT BRITAIN AS THE BIRTHPLACE OF COMICS

Generally recognized to have originated in England beginning with British satirists, the art of comics was never considered respectable at any socioeconomic level. In the canon of great literature, especially during the Victorian and Edwardian eras, comic satire ranked close to the very bottom. The reasons for this are about as complex as British society.

One of the reasons is that because comics were visual and included pictures, they were considered a threat and a detriment to the reading of great books. The middle-class patriarchy claimed that working-class literacy levels were at stake, and that poor people should be encouraged to read books designed to improve themselves. By this they meant publications without pictures and writings by the established British pantheon of respectable authors. Anything with too many pictures was thus declared inferior by its very nature.

So, although Britain is considered the official birth-place of the comic, the fact that comics existed at all was at most only tolerated. The term "comic" came to mean "jolly fun," according to Roger Sabin in *Adult Comics*, but this term always carried derogatory associations, and this definition has more or less persisted into the present day.

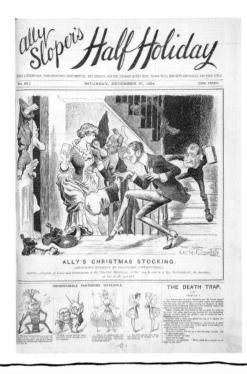

Ally Sloper's Half Holiday, a cover from which is shown above, was a revolution in comics. Sloper is widely known as the first comic strip character, and he became part of England's national fabric, a hero of the working class.

getting into trouble but always finding his way out of it to his own advantage. He is thought to have been modeled after Mr. Micawber, a character from the English writer Charles Dickens's well-known novel *David Copperfield*. Ally Sloper also reflected the antics and characters who frequented the plentiful pubs and music halls of the time. As Roger Sabin puts it, he was "the ultimate Victorian anti-hero, and articulated a working class life rarely touched upon in other publications." Sloper's name was a pun on the Victorian age practice of "sloping" up the hill to avoid the rent collectors.

Because this popular comic so deftly expressed the people's feelings during the time, it became a

The publication of *Comic Cuts* in 1890 was the beginning of the comic boom in England, when publishers such as Alfred Harmsworth churned out cheap comics inspired by the success of *Ally Sloper's Half Holiday*. Although these comics usually cost only a half-penny, they were intended for an adult audience.

huge success across the range of the white-collar and blue-collar classes. It even reached a cult status among middle-class intellectuals. With such a huge readership, it fast became "the largest-selling penny-paper in the world," as was proclaimed across its front, selling an estimated 350,000 copies per week. Like today's films and cartoon characters, Ally Sloper could be found on all kinds of merchandise: watches, mugs, pipes, and other goods. The character was Great Britain's first comics star.

Later in the century, the publisher Amalgamated Press began to capitalize on the groundbreaking *Half*

Holiday comics. *Comic Cuts* (1890–1953) and *Illustrated Chips* (1890–1952) took cues from the working-class hero in the form of Sloper and blatantly plagiarized *Half Holiday*, selling for only a half-penny a copy. To keep costs down, cheap materials were used, and material was lifted from U.S. and British magazines, usually without permission.

Interestingly, *Cuts* and *Chips* were also responsible for redefining comic book art. Tom Browne (1870–1910), who did the artwork for *Cuts* and *Chips*, was an excellent artist who created other well-known Victorian characters, such as Weary Willie and Tired Tim. If the characters and the stories were stolen from other sources, Browne's artistic style was unique. It was clearer, less adorned, with much less shading than most Victorian drawing. Browne understood that an uncluttered and less adorned technique flowed better in an illustrated strip, thus setting a style that would be highly imitated. He is acknowledged as Britain's first major comics creator.

Despite cheap and cut-rate production and plagiarism from other publications, *Cuts* and *Chips* went on to become extremely successful, showing that even with very low prices, if the circulation of a publication was high enough, a huge profit could still be made. According to Sabin in *Adult Comics*, "It is usually agreed that their spectacular sales make the point historically where comics became a 'mass' medium." Amalgamated Press owner Alfred Harmsworth later went on to become one of Britain's biggest tycoons, launching the newspapers the *Daily Mirror* and the *Daily Mail* from his comic-book profits.

THE GODFATHER OF MODERN BRITISH COMICS

Bryan Talbot was born on February 24, 1952, in Wigan, Lancashire, England. He was an only child, and he spent a great deal of time by himself while his parents were working. His parents encouraged him to draw and introduced him to comics by getting him *Jack and Jill*, a weekly comic for nursery-age kids, to encourage his reading. Later, they bought him DC Thomson comics such as *Beano* and *Beezer*. Every Christmas, his dad bought him the *Rupert the Bear Annual*, a popular British comic publication.

Talbot says, in an interview published on PopImage.com, a Web zine dedicated to comic-book culture,

[I] always read comics, since before going to school, and [I've] always drawn. When I

was a kid I'd draw comics for my own amuse-
ment; I'd staple together typing paper, folded in
the middle, and start drawing a story, making it
up as I went along. When I reached a few pages
from the end, I'd wrap up the story. At junior
school, a teacher once "commissioned" me to
produce one of my comics for him . . . didn't pay
me anything, though!

Further art education experiences proved to be
frustrating. Art lessons in grammar school consisted
only of the teachers or instructors giving their pupils
large sheets of paper and telling them to draw. Even
through this lack of instruction, Talbot focused at an
early age on doing cartoon-like figures.

Although he didn't do well on his art exams, he
continued on to Wigan School of Art, intending to do
a one-year course of study in the foundations and
basics of art. Unfortunately, he didn't learn much there,
either. Nor was he very happy. "I was taught there
by three exhibiting abstract artists who had a total
horror of figurative art," he said. Abstract art was an
extremely trendy mode of artistic expression at this
time, and realism was looked upon as outdated and
old-fashioned. As a result, all Talbot did was make
abstract painting and drawings during his time at
the school.

After this period, Talbot remembers failing to be
accepted at all of the fine-arts colleges he applied to,
perhaps because he wasn't excited enough with the
portfolio of abstract art he showed at interviews. At

the very last minute, however, he managed to be accepted into a graphic design program. After starting school, he realized too late that no illustration or traditional figurative art was taught there. There wasn't even a life-drawing class offered.

He did develop skills that would help him in his future profession, though, such as typography, layout, and how to use technical pens and airbrushes. But he was on his own when it came to developing his talent in illustration. After he had finished with his classes for the week at school, he would spend hours in the library. He checked out books on art, perspective, composition, and anatomy and learned what he expected to be taught in college.

Although Talbot advises young people who want to become artists to continue with college, his own experience was so disheartening that he also suggests that they seek out their own resources and do some planning. The important thing is that their area of emphasis coincides with their interests and what they plan to do for a living. In his case, he says, he should have majored in illustration, since he ended up in comics.

Talbot's first published work surfaced in the British *Tolkien Society Magazine* in 1969, while he was still in college. He also produced a weekly comic strip for the college newspaper, a collaborative effort with a friend and fellow student, a cartoonist known as Bonk. Unfortunately, he never realized he could make a living doing comics. He just knew that he wanted to work in art somehow. "It was only after I finished college, when I was unemployed, that I started drawing comics for the underground market."

When Talbot finished college, he was published in the underground press for five years, drawing and writing the *Brainstorm Comix* for Alchemy Press. He states:

> It was just about the end of the underground period when the new "ground-level" or "alternative" comics were coming about, and material influenced by European comics like *Metal Hurlant*, *Heavy Metal* and *Epic Illustrated*. Mainstream comics at the time, with few exceptions, were pretty dire—dull and predictable superhero stories, bland melodramas with no blood, sex or swearing, and no depth of story.

The Modern Comic Era Begins

During the first half of the twentieth century in England and the United States, comic books were marketed solely to children. Comics of that time developed the characteristics of comic books that most people think of today—juvenile, naive stories, stretching into subject matter other than humor. There was a great variety of titles and styles available for consumption during this time, producing superheroes such as Superman and the Incredible Hulk, that we still recognize today.

All of that changed in the 1960s, when the underground movement created a revolutionary departure from mainstream comics. This was a new breed of comics, geared toward adults, reflecting the changing nature of the times, and redefining exactly what a comic book could include and encompass.

1970s SOCIAL AND POLITICAL INFLUENCES

Perhaps the best way to understand the advent of the underground comic movement is to understand the profound social and political changes that took place in the 1960s and 1970s in both Britain and the United States. These years are best remembered for the culmination of the civil rights movements for minorities and for women; the Vietnam War, the United States' involvement in it, and the mass protests against it; new sexual freedoms; and the use of experimental drugs for pleasure and supposed spiritual awakening.

The counterculture of the United States and Britain at this time sought to replace traditional society's norms and abuses. At its best, it hoped to replace what was viewed as a reactionary dominant culture with one that was more egalitarian, idealistic, and peaceful. There is no denying that this political and social movement affected every aspect of the arts, from literature to film to music to comic books.

Comics (sometimes written as "comix" or "komix") produced outside of the mainstream industry mirrored these changes in society and produced titles specifically on adult themes, such as sex, drugs, and radical politics. Although intended for a very particular audience, they invariably changed the face of the comics industry forever.

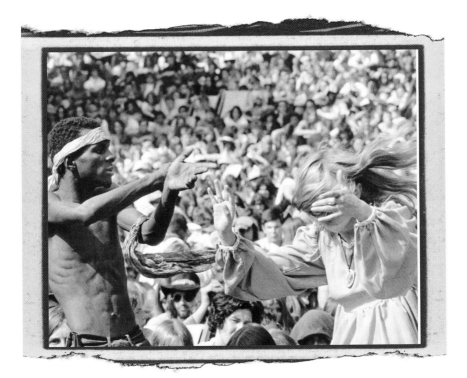

The 1960s and 1970s were decades of great change in England and the United States. Although a counterculture certainly was nothing new in either country, the underground movement was especially strong during this time, influencing various forms of creative expression including comics.

Underground culture in Britain quickly began to develop alternative presses, putting out newspapers and magazines that used graphics more freely than the mainstream dailies and periodicals, though they were not officially comics. Examples of these types of publications were *IT* (*International Times*) and *Oz*, plus illustrated radical pamphlets, some with poetry, like

that of Jeff Nuttall, a British poet, painter, and perform-
ance artist. But since Britain had long associated comic
books with children's themes, there was a reluctance to
use the medium to produce work for adult audiences.
The very first underground comics actually made their
way out of the United States.

These first alternative comics were self-published
zines, usually not intended for distribution on a large
scale. They were often produced on college campuses,
perhaps influenced by humor magazines such as *Mad*.
Some U.S. newspapers, such as the *Berkeley Barb*, *LA
Free Press*, and *East Village Other*, began generating
alternative comic strips as well.

The first well-known underground comic in the United
States appeared circa 1968, out of the hippie culture in San
Francisco. It was called *Zap*, and was created by
Robert Crumb. Its characters were caricatures of
mainstream culture figures. There was Whiteman, a
racist, establishment-oriented pillar of the community;
Angelfood McSpade, a racist caricature; and Mr.
Natural, a people-hating capitalist. According to Roger
Sabin in *Adult Comics*, Mr. Natural's character was
"a satire on the gullibility of the love generation, and a
cipher for the intellectual conundrum, 'how do you
"teach" wisdom?'" Further, as stated in *Adult Comics*,
Zap was probably the comic that inspired other artists
to create their own comics and got the underground
ball rolling in the United States and Britain.

After key creators had established the movement,
subject matter and themes started to change and
expand. Underrepresented groups, such as women,

Robert Crumb, photographed in 1985 in his home studio, is one of the most influential comics creators in modern history. Born in Philadelphia in 1943, Crumb was an avid drawer with no formal art training. His comics were stinging but humorous social commentaries of life in the United States, and he became a leader in the underground culture of the 1960s and 1970s.

began to create their own comics. The first comic dedicated to women's causes was *It Ain't Me, Babe,* created by a group of women at University of California at Berkeley, circa 1970, followed by *Wimmen's Comix,* created by a group of women in San Francisco in 1972. These comics were largely a feminist reaction against what they believed was sexism in the first underground comics, including the work of Crumb. The new so-called cause comics also included titles about the

politics surrounding nuclear power, environmental issues, and gay liberation.

By the early 1970s, the underground movement was well under way. There were publishers such as Kitchen Sink, Rip Off, and Last Gasp that produced nothing but comics. At lower levels, self-publishing was more popular than ever before. When the movement first arrived in Great Britain, it was forceful, finding an immediate response among England's own hippie culture, particularly on college campuses. The work of Robert Crumb was especially in demand.

The First Real British Comics

British creations, however, took a while to get firmly established. The very first, *Cyclops*, was a tabloid started in 1970 by a group of people who worked on *IT*, with Graham Keen in charge. It printed American work alongside new British stuff and was considered very up-and-coming and hip. However, it lasted only four issues, probably due to its high price.

The next try was with *Nasty Tales*, circa 1971, which included both American and English work, but had a sillier, yet more radical, sensibility. British creators included in the publication were Edward Barker, Malcolm Livingstone, and Chris Welch. Unfortunately, the publication was canceled, surrounded by controversy, by 1973.

Cozmic Comics was next to debut in 1972 and was probably the best known and longest running of the British underground movement. It was produced by

WORLD COMICS

Many people are surprised to learn that comics and graphic novels are published in countries other than the United States and England. The truth is, there are entire continents of comics to discover.

When the term "world comics" is used in England and the United States, it usually means comics originating in Japan or Europe. This is because the comics in both these cultures are highly developed and provide the kind of stories that English-speaking readers prefer and are comfortable with. But a whole world of comics exists outside of this sphere as well. In Mexico, for example, it is estimated that 80 percent of all magazine or periodical publishing is actually comics, most of it intended for adult readers. Bombay, India, the moviemaking capital of that country, is also the center of its comics industry, turning out comics of all ranges and for all age groups, including religious graphic novels.

In Africa, China, South America, Southeast Asia, the Philippines, and other countries and regions around the world, comics are an active part of the culture.

an offset of *Oz* magazine and was created in part to make money for the publication, which by this time was financially ailing. More than twenty titles were created, with a number of important British creators showcased, including Dave Gibbons, Brian Bolland, Angus McKie, Mike Weller, Edward Barker, and Joe Petagno, many of whom would later make names for

themselves in mainstream comics and comics aimed at adults.

Brainstorm Comix (1975) marked the first official all-British comic, with its first issue announcing proudly, "Made in Britain." It was created to become a vehicle for one comics creator in particular, Bryan Talbot. Roger Sabin explains it best in his book *Comics, Comix, and Graphic Novels*:

> There had been other British underground comix before this date. But *Nasty Tales* and *Cozmic* line (all of which heavily featured material from the United States), had had their day, and there seemed to be a hiatus in activity around 1974–5. *Brainstorm* broke the silence, and was immediately different because it included no U.S. strips at all . . . Not only this, but the art was better than most undergrounds . . .

Talbot, then an unknown artist from Lancashire, is modest about this first underground work. In an introduction to the collected volume of *Brainstorm*'s first three issues, *The Chester P. Hackenbush Trilogy*, he says:

> I think of this first published work as my apprenticeship in the comics medium and freely admit that I made all my mistakes in print. See, I'm self-taught. That is to say, I was taught by a very ignorant person, indeed. Of course I had the same acquired knowledge of comics grammar as anybody who'd spent their life reading them but, as for the actual drawing, I'm a slow learner.

Some artists seem to arrive fully formed. I'm
still learning.

There was a great deal that was special about this
first official British underground comic. Although
there were vestiges of American comic style (particu-
larly that of Robert Crumb), it had a particularly
British sensibility, reflecting the hippie and music culture
that surrounded Portobello Road, London, and the
Mountain Grill café, circa 1975, when "freaks"
and "heads" were everywhere, drug deals were made,
and plans were discussed.

Brainstorm Comix number 1 not only reflected this
culture, it was a product of this culture. Here were the
main players: a psychedelic comic published by
Alchemy, and a head shop owned by Lee Harris on
Portobello Road, which is still open today. Talbot met
Harris one day in 1973, when he was in London to
submit a comic strip to *Cozmic Comics*. The work was
accepted, but Talbot never heard from *Cozmic* again
and was never paid, either. Harris had told him rashly,
according to Talbot's intro for *Hackenbush*, "If you
ever do a comic, I'll publish it."

Chester P. Hackenbush

Two years later, in 1975, it seemed like Talbot's life
had come to a dead end. He'd finished college and had
been unemployed for about a year. He had a wife,
Mary, and two young sons, Robin and Alwyn, to
worry about. Talbot considered getting a job as a

trash collector, but in the end, he decided to see about doing a comic for Lee Harris.

While still in college, Talbot had already finished four pages of what was to become the first issue of *Brainstorm*. He redrew two of these pages and finished the other sixteen in about five months. He picked the name "Brainstorm" out of *Roget's Thesaurus*, attracted by its reference to insanity. Then he hitched a ride to London from Preston, Lancashire, and presented the work to Harris who, true to his word, published it. He also told Talbot to get to work on the next one, and thus, Bryan Talbot's career in comics began.

The comic's main character, Chester P. Hackenbush, became a counterculture hero. His entire reason for existence, in this comic that extols the virtues of psychedelic culture, was to consume as many drugs as possible. Instead of killing him, the drugs would cause a pretty heavy trip, and he would go into a make-believe world, Euphoria, where he would meet all kinds of freaky characters and philosophize on the nature of the universe.

Though we giggle about this sort of stuff today and are aware of the dangers associated with taking illegal drugs, the counterculture of the 1960s and 1970s genuinely saw taking experimental drugs as a possible way to achieve spiritual enlightenment, as well as a recreational activity. *Brainstorm* mainly featured LSD and marijuana, held in an almost sacred regard, as a way of opening the doors of perception.

Brainstorm quickly gained a readership. Members of the counterculture were its main following, but older members of the comic book industry also admired it.

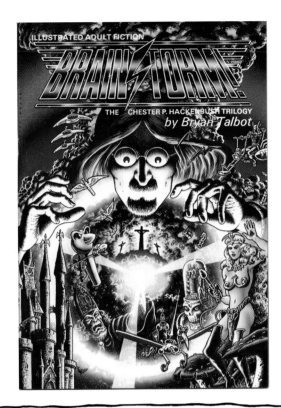

This is the cover to the single volume edition of the Chester P. Hackenbush trilogy, titled *Brainstorm*. It was first published in 1982. Talbot's friend, graphic novelist Alan Moore, paid tribute to Hackenbush with his *Swamp Thing* character Chester Williams.

One fan was Alfred Bestall, a comic creator in his eighties who authored *Rupert the Bear*, the very same comic Talbot had grown up reading. Bestall signed a copy of *Brainstorm* for Talbot at a book fair, adding the phrase, "I am very intrigued," according to Sabin in *Comics, Comix, and Graphic Novels*. Talbot has kept the signed issue to this day.

Due to *Brainstorm*'s illegal content, it wasn't stocked on mainstream newsstands or magazine racks. But in the underground circuit and illicit head-shop venues, it

did very well, peaking with a circulation of 12,000 per issue. It didn't exactly make Talbot rich, but because of it, his career was set in motion.

The Punk Scene Arrives

The year 1977 marked the arrival of the punk scene, and with it, some major changes to popular culture. Hippies, long hair, dope, and (by its close association with the previous wave of counterculture) comics were pushed aside in favor of angry, chaotic, and violent displays of expression.

One of Talbot's old friends, the cartoonist Andy Johnson who was vocal in his support of the new punk movement, published articles claiming that the old comics were just drivel, suggesting that Talbot and *Brainstorm* were out-of-date. Understandably, especially since this was coming from a friend, Talbot was hurt. In response, he created a comic strip portraying Johnson as a crying infant, with a safety pin, a symbol of the punk movement, holding up his diapers, and called it *Komix Comics*. Despite this fight via print, the friendship was later mended.

Ultimately, Talbot's response to the punk movement was "The Omega Report," issue number six of the *Brainstorm* series. "Omega" blended rock and roll, comedy, and a sci-fi detective story together, and it proved to be popular. Both the concept and the plot were done well in advance of other comics of its sort. The artwork was done to mimic the look of black-and-white private eye

movies "by inking heavily with a brush and using lots of mechanical tints in attempt to create a film noir atmosphere," according to Talbot in his preface to the *Brainstorm* reprint.

He is now not really satisfied with it. He says, "I'd never inked with a brush before, and it took me three months to realize that it was supposed to go to a fine pinpoint at the end."

Roger Sabin, as a comic historian, states that looking back in retrospect, "we can see that the punk and hippie movements were not far apart . . . But at the time, it seemed as if something had changed and that the underground could not continue in the same vein." Andy Johnson's idea for a new wave of punk comics never occurred as he envisioned it. At the same time, the hippie, sex, drugs, and political comics started to disappear, including Bryan Talbot's head-shop-produced *Brainstorm* comics. From this point forward, the word "alternative," which seems so familiar to us today, would also come to indicate comics that didn't fit into the traditional vein.

But Talbot was already looking to the future. As early as 1977, his subject matter was pointed in a new direction, away from the psychedelic and toward science-fiction–oriented work. Issue three of *Brainstorm*, "Mixed Bunch," contained a new character, the first mention of Talbot's famous Luther Arkwright. The work was also unique in that it introduced a new washlike artwork and hinted at Talbot's talent for storytelling.

The *Brainstorm* era officially ended with the collapse of the comic in 1978, which essentially coincided

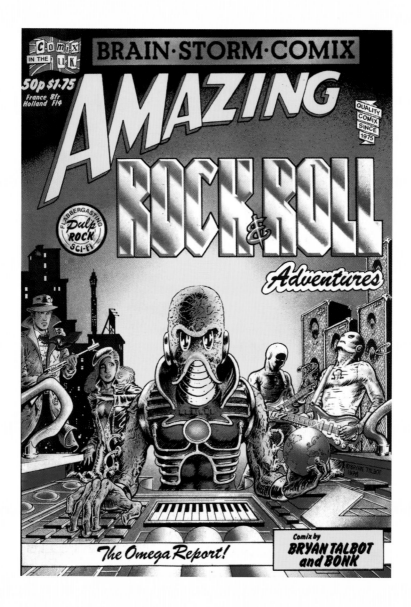

This is *Brainstorm* issue number six, "The Omega Report," Talbot's early triumph blending a variety of genres. The comic was a great leap for Talbot, in terms of both his technical skill and the content of his work. "The Omega Report" was a sign of the times, reflecting social changes and shifts in popular culture.

with the collapse of the hippie movement. However, *Brainstorm*'s importance continued long after the final issue was printed. It influenced many other creators, such as Alan Moore, Neil Gaiman, and Grant Morrison, and served to speak as the voice of a cultural generation. In a sarcastic bit in the preface to the *Brainstorm* reprint, Sabin relates:

> Portobello Road is still there, but it doesn't have the same atmosphere that it did. The Mountain Grill is long gone, the graffiti has been cleaned up, and the area has become so yuppified that it was recently used as the location for the grim Hugh Grant comedy *Notting Hill*.

Still, he says, "Alchemy continues to ply its dodgy trade, and for the price of a cup of herbal tea, Lee Harris can even now be found ready to discuss ye good ole days."

GOING MAINSTREAM

uring the heyday of underground comics in the 1960s and 1970s, the mainstream publishers in Britain and the United States had never wavered from their rut of producing comics only for children. It is interesting, then, that it was a children's comic that eventually got the ball moving toward adult readership and reversed the trend in the commercial comic industry.

A children's science-fiction weekly named *2000 AD* proved to be the answer that the industry and fans needed. According to Roger Sabin, it formed something of a bridge from the underground movement of the 1970s, introducing a number of new comic creators to a larger adult readership. The influence of *2000 AD* cannot be overstated. The comic brought changes to the industry that no one could have forseen.

Talbot acknowledges this, in an interview with an Italian fan on his official Web site:

Towards the end of the '70s, underground comics were dying out, or changing into "alternative" titles like *Near Myths* . . . *2000 AD* was where it was all happening; exciting stories full of black humour, experimentation and brilliant art by the likes of Brian Bolland, Dave Gibbons and Glenn Fabry. Writers like Alan Moore, Alan Grant, Grant Morrison and many others honed their craft there to perfection.

The *2000 AD* Story

The popularity of *2000 AD* actually begins with a comic entitled *Action*, an action-adventure comic aimed at young boys that was started circa 1976. However, *Action* was not a typical comic geared toward your typical Boy Scout. Editor Pat Mills deliberately aimed the themes toward street-smart kids familiar with contemporary movies of the time, like *Jaws*, *Dirty Harry*, and *Rollerball*. *Action* featured material and characters stripped directly from these pop-culture movies in the form of killer sharks ("Hookjaw"), killer cops ("Dredger"), and killer science-fiction games (Death Game 1999). Ironically, all of this material was taken out of movies that the target audience was not allowed to see without a parent or legal guardian, which upped the cool factor considerably. A caption over the title of the comic read, "This comic is NOT suitable for adults."

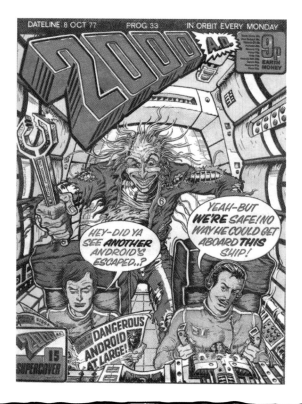

This comic was violent, cynical, and gory, and also extremely successful. The amount of fan mail received by its publisher, IPC, is legendary. At its peak, *Action* sold a steady 150,000 copies per week. And most historically important, according to Roger Sabin, it broke the unwritten rule that children's comic books needed to be silly, harmless, light, and fun.

Not long afterward, however, *Action* fell under heavy scrutiny, and an almost inevitable censorship campaign was headed by Britain's *Sun* newspaper,

along with condemning TV and radio reports. And although it might be thought that cracking down on the violence to protect the children might have been the main impetus, it was actually *Action*'s blatant challenge of authority that the censors had the most trouble with. After *Action* toned down its content, under pressure from various public and governmental entities, it became just another bland adventure title and was eventually phased out due to declining readership.

In 1977, *2000 AD* was created as a companion science-fiction title to *Action*. The editors planned to reintroduce an *Action*-type comic, while avoiding the previous controversy. The comic featured TV- and movie-oriented themes also, with a story called "Mach 1" that was influenced by the popular television show *The Six Million Dollar Man*. "Mach 1" featured a character, Judge Dredd, that would become as well-known as the title *2000 AD* itself.

The stories were cynical science-fiction adventures that were staged in the future in the hopes of avoiding the criticism and censorship that had befallen *Action*. The new comic also had a more humorous bent, with writers John Wagner, Alan Grant, and Pat Mills bringing a tongue-in-cheek tone to the stories. Also, from the start, *2000 AD* was flashier than anything being done in Britain at the time. Its artists were allowed to experiment more with their medium, stylistically bringing the comic closer to their American counterparts, such as *Love and Rockets* and *Elfquest*, both of which were U.S. imports popular in Britain during the time and doing phenomenally better than the sluggish British works. *2000 AD* featured covers that were visually extravagant and

COMIC BOOK CULTURE

According to Matthew J. Pustz, some readers of historical and contemporary comic books fit into the traditional idea of "fan," while others do not. Some describe themselves, mockingly or not, with the nickname "fanboy," used basically in the same way *Star Trek* fans are apt to call themselves "trekkies." Some prefer to identify themselves as consumers only of alternative comics, which can be defined as anything published outside the realm of the mainstream publishers, such as DC Comics or Marvel comics.

However, it is probably safe to assume that although diverse, readers of comics are probably more united by common interests than they are held apart by separate threads. Much of this is due to their love of a medium that is scorned by the mainstream.

Although the peak of fandom may have come in the 1970s, the heyday of the alternative comic, the present-day comics culture has its own formalized fanzines, comic shops, discussion groups, and comic-book conventions. There's a lot of activity on the Web, with individual creators' official Web pages, as well as fan pages and tributes.

For quite a few people, being a comic-book fan is part of a person's identity. Some fans appear to want to announce that identity, for example by wearing T-shirts proclaiming this, while still others like to keep that identity a secret. For a few, being a comic fan is something painful, as they believe that most of the rest of American society looks down on them and their interests.

larger comic panels, making the typical British model of evenly measured strips look outdated.

Despite its thematic differences and artistic experimentation, *2000 AD* was not an immediate commercial success. Although issue one of the comic sold out, the sales went into sharp decline after that, so much so that the publishers almost decided to stop producing it. But *2000 AD* would not be put down. Perhaps its daring and edgy attitude, more than anything else, was what got it noticed, particularly by members of the previous underground comics movement.

Creators including Dave Gibbons, Brian Bolland, Kevin O'Neill, and Bryan Talbot all came aboard. They recognized something they could identify with in the comic, especially under the editorial wing of Pat Mills, who was seen as something of a maverick in the industry. For many creators, *2000 AD* represented a valid way to make a living, because although still tied to the old work-for-hire tradition, or pay by the piece, there was at least an allowable amount of self-expression attached to a moderate profit. In other words, freedom of artistic expression, fame, and monetary reward were at least of some consolation to a creator. This was certainly the case for Bryan Talbot, who, of course, wanted to make a living from his chosen career, and who was without a publisher after the *Brainstorm* era ended.

With the addition of the underground artists, the sensibility of *2000 AD* rose to a more sophisticated level, effectively saving the future of the comic. With the help of the underground creators, *2000 AD* began its golden age, roughly from the end of 1978 to 1985. New

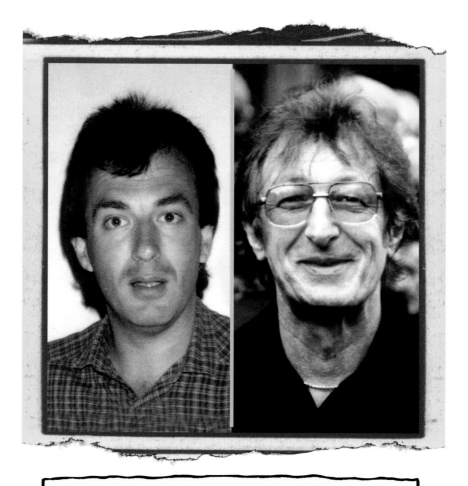

Dave Gibbons *(left)* and Alan Grant *(right)* were two of the creators who worked on *2000 AD*. Along with Bryan Talbot and others, they helped shape the style and set the tone for the comic. Gibbons is perhaps best known for his work with Alan Moore on the groundbreaking graphic novel *Watchmen*. Grant is a successful comics writer who has scripted stories for *Judge Dredd* and *Batman*, among others.

adventure stories were begun, many depicting hard-boiled science-fiction violence with names like *Rogue Trooper* and *Strontium Dog*, both set amid bleak, apocalyptic futures. Bryan Talbot's contribution to this era included *Nemesis the Warlock*, in conjunction with Pat Mills and Kevin O'Neill. It is an underdog story with aliens as heroes and human beings as villains, making a

serious point about racism and imperialism while being darkly funny. The *Nemesis* stories were reprinted by Titan Books. The first garnered Talbot an Eagle Award for Best Graphic Novel, and the character Torquemada won the Favorite Villain award for three years straight.

However, dominating all these stories was the character Judge Dredd, who was clearly the star of *2000 AD*. Dredd ruled over a thinly disguised New York City (Mega City One) in a futuristic science-fiction metropolis. He was written as a fascist character whose famous catchphrase was "I am the Law." The stories were ironic and raised questions about the nature of power, all the while keeping the Judge Dredd character as amusing as possible.

Talbot worked on the Judge Dredd comic with Alan Grant and John Wagner for a few months. His contributions included full color-strips for IPC annuals.

The style of this comic was unique and reminiscent of the underground, a mix of American flash and British confidence. One cocreator recalls, in *Adult Comics*, that "we were all very enthusiastic about each other's work, and I think that sense of pride in what you were doing was passed on to the readers. This was a friendly rivalry, but we also sparked off each other. There was definitely a positive attitude."

2000 AD's readership could be divided into three categories. First was the primary target group, children, who liked the action-adventure side of the stories. Second were American teenagers, who appreciated the comic mainly for its artistic style, which was similar to American comic-book styles. Third, and perhaps the

most important group historically, was the adult reader-
ship group, who liked the dark humor, sophistication,
and almost underground attitude of this new comic.

Publications often featured stories on *2000 AD*,
and journalists played up the sophisticated aspects of
the comic. As the 1980s progressed, the line between
2000 AD as being either a kid's or adult's comic was
further blurred.

During the next few years, challenges to *2000 AD's*
popularity came and went. Something that severely
challenged the comic's market share, however, came in
the form of American specialty comic-book shops that
devoted themselves almost entirely to American prod-
ucts. These included new superhero titles such as *New
Teen Titans* and *X-Men*. By this time, *2000 AD* was
beginning to look a bit dated. U.S. compa-
nies Marvel and DC became the new
glamour in comics, and *2000 AD*
began to lose readers as time
wore on.

This is one of Bryan Talbot's draw-
ings of Judge Dredd. Judge Dredd
was arguably the most popular
character from *2000 AD*.

In addition, these American companies began to offer higher rates of pay to creators, leading some of *2000 AD*'s best talents to better offers. Creators at *2000 AD* could expect the industry's traditional working standard, a flat fee per page, without royalties or rights over the work. With American comic publishers, it was possible to get royalties.

IPC refused to change, and *2000 AD* eventually paid for the publisher's mistake. U.S. companies offered more money and more rewards, too, in the form of fame. The British publisher just couldn't match the money and potential fame its American competitors offered. In time, the creators defected en masse to the American side of the pond. Members associated with this group were often called the Brit Pack and would be central to the importance of the adult comic boom in the future.

Roots of the Graphic Novel

The term "graphic novel" was actually not used commonly until about 1986 or 1987. However, graphic novels did not spring into being as suddenly as publishers and those with an interest in marketing comics would have the public believe. The graphic novel is a genre with an illustrious history.

Roger Sabin writes that there are actually three distinct types of graphic novels. The first is what we think about when we interpret the word "novel," a finite, book-length publication with a continuing narrative and comic illustration. A second kind of graphic

novel is a serialized work, or one in which the contents have already appeared separately in a comics anthology or elsewhere, and are then collected into one volume as a graphic novel. The third kind can be likened to a soap opera serialization, a collection of anywhere from four to twelve installments in a single volume, for which the creator had a vision of working consciously toward a larger whole. The common element of these three types of graphic novels is that they are thematically unified.

As comics became adult oriented, the expansion of the graphic novel began. Three distinct influences had an impact on the genre coming about: the influence of European comics album artwork of the 1970s and 1980s; maverick comic creators working in a nontraditional, longer format before this idea became acceptable to the mainstream; and the fact that adults read books within the market. All three of these were present against the backdrop of the underground movement. Not only did the free intellectual atmosphere influence adults to read comics, but it also influenced creators to think out of the box, to bigger and better things.

In Europe, from the mid-1970s on, an adult comic culture developed where works designed to be published as album covers were actually published first in periodicals, a few pieces at a time. This created an unprecedented acclaim for the artists, who also received royalty payments for their work. After a time, the artists themselves became so well-known that the albums themselves could be marketed on a creator's reputation.

Unlike the mainstream production of comics in both the United States and England, the European market had more of a tradition of quality over quantity in producing comic artwork. These European albums were imported into England and the United States and had a big impact on the creators of the underground. This European influence was important in Britain and the United States because the sales of these albums were huge. Sales of 50,000 for a single album were common. Also, both the British and U.S. authors were inspired by the fame and respect that the European creators received, the financial rewards that might be expected, and the freedom of expression the work seemed to warrant.

From these influences and motivations, several American and British creators began to experiment with longer comic narratives. They could be termed mavericks in that they were true, creative spirits who were willing to think outside the already categorized genre and create a new form. These mavericks were responsible for what the comic form has evolved into in the present day, and among this group was Bryan Talbot.

Luther Arkwright

Talbot was already ahead of the game in regards to adult comics as early as 1977. In his third issue for *Brainstorm Comix* back during the underground period, he had debuted a character that was to prove one of his most popular and which remains one of his most outstanding achievements.

This was a complex story set in a sci-fi parallel universe in Britain, where the country was under a Catholic dictatorship. The comic is described within its pages as where, "Henry IX was a tyrant, a religious fanatic . . . " and where Luther Arkwright, a "mercenary and infidel," is the only hope of "maintaining the equilibrium of the parallels." The humor, similar to the Chester P. Hackenbush character, was still there, with sexy biker nuns and a Nazi bishop making an appearance, but there was a serious element as well.

In particular, according to Roger Sabin, in his introduction to the *Brainstorm* reprint (1982), which features a collection of Talbot's comics from the underground era, "Bryan had seen copies of *Metal Hurlant* [later translated into *Heavy Metal*], and he had been 'knocked out' by the ways in which artists like Moebius and Bilal had taken the science-fiction genre in comics and reinvented it in adult form."

In the late 1970s and early 1980s, Talbot began to expand and improve the *Arkwright* story to the point where it became a pioneering series of graphic novels. *Arkwright* is largely recognized as the first true British graphic novel published. (Although Raymond Brigg's *When the Wind Blows* was published during the same year in England and was commercially successful, it was an adaptation of a preexisting literary narrative work, whereas Talbot's *Arkwright* is an original conception.) It was distributed by Never, Ltd., in 1982.

Comic-book creator Alan Moore heaps praise on *Arkwright* on Talbot's official Web site. "Bryan Talbot's *Luther Arkwright*, in both content and technique, has

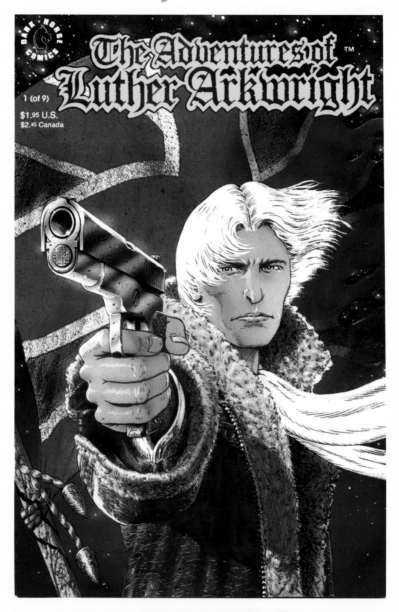

This is the cover of the Dark Horse edition of the first issue of *The Adventures of Luther Arkwright*. This issue was sold in the United States and Canada, and was drawn expressly to cater to those markets. The British cover for the same issue (published by Valkyrie Press) was an entirely different style: Arkwright looks more like James Bond than a dangerous killing machine, and the cover art is more ornamental and colorful.

METAL HURLANT

One of the most artistically influential comics ever created came not from the United States or Great Britain, but from France. A comic boom in France had occurred, inspired by the comic underground movements abroad.

Metal Hurlant (1975) literally means "screaming metal." This comic was glossy, openly erotic, and a visually stunning work produced monthly. It showcased the work of various European creators, including Phillippe Druillet, Enki Bilal, and Moebius.

Since the comic was written in French, it was not a large commercial success. However, it was imported to head shops and comic specialty stores, where it found an eager and loyal audience. *Metal Hurlant* was unlike anything anyone had seen before, and it made an impact on the comic world second only to underground comics themselves.

Above everything, the artwork in *Metal Hurlant* was unparalleled. Many of the strips were completely painted using airbrush techniques, and it was all printed on high-quality glossy magazine paper. "France," Roger Sabin concedes in *Adult Comics*, "was prepared to treat comics with a respect they lacked in Britain and the U.S."

always been a good decade ahead of its time. Today, in a marketplace that has finally caught up, it should find the audience it so richly deserves."

And this from comics creator Michael Moorcock, also found on Talbot's Web site: "Here is something far more original and idiosyncratic than anyone has attempted before . . . an alternative history of modern times. And of course, because Talbot uses a popular form to do this, it is also a very good, romantic, inventive, fast-paced yarn."

The Adventures of Luther Arkwright opened the door for Talbot during this period for work of a more commercial vein. In addition to joining the Brit Pack to work on the *2000 AD* venture, he went on to do collaborative and illustration work with various writers and creators, especially for the United States' commercial giant, DC Comics.

AMERICAN, COLLABORATIVE, AND ILLUSTRATIVE WORK

As has been noted, it is possible to trace the modern era of adult comics in the United States back to the underground movement of the 1960s. It is not surprising, then, that the Brit Pack, including Bryan Talbot, was a group of highly influential creators during the modern era's start.

The modern comics era started in approximately the mid-1970s and continues to the present day. Like the underground movement, the comic-book shop and fan culture started in the United States. Fans of the superhero comic books of the early 1960s began collecting issues, starting a whole new culture. The first fanzine probably appeared in the United States around 1961, and the first fan convention took place in New York City in 1964. The very first comic-book shops started to appear on the West Coast, in the San Francisco Bay area, in the late 1960s.

From an American perspective, the influence of the Brit Pack during this time was probably not as drastic or dramatic as British fans and creators believed. It was said that the British creators, including Bryan Talbot, were so talented and in demand that they were responsible for the turnaround in American comics. Likewise, British comic characters were often interpreted differently by American fans than they were by British fans. The Judge Dredd character became well-known in the United States in the 1980s, but the British humor was mostly lost on the American audiences. According to Dredd creator Alan Grant, as quoted in *Adult Comics*, "Because American audiences are used to superheroes who are done dead straight, without any irony, I think they missed the point when Dredd came along, and saw him simply as a shoot-'em-up fascist—which is a little worrying, really."

The comics revolution in the United States received coverage in major newspapers and magazines, including *Time*, *Newsweek*, and the *Wall Street Journal*. Comic-book publishers' public-relations campaigns also piqued interest. One major advertisement by DC Comics read, as quoted by Roger Sabin, "You outgrew comics—now they've caught up with you!"

As comic books boomed in the United States, the main producers were publishers Marvel and DC, with other independent publishers jumping onto the bandwagon. This was a complete renaissance, with adult comics coming into the mainstream unlike anything that had been seen since before the Comics Code, the industry-enforced censorship in effect in the United States since circa 1954.

DC Comics and Collaborations

For major publishers, one of the benefits that resulted from the increase in comic-book stores and the comic culture was a better understanding of who was reading comic books. This allowed small publishers to flourish and increase, and also allowed large companies to research the reading market. Superhero comics were still popular among mainstream American comic audiences, but it was at this point that publishers began to think of ways for superheroes to appeal to adults, as the audience was moving into its twenties.

In addition, the effect of the American Comics Code was also loosening. Both of the United States' large comics publishers, Marvel and DC Comics, were testing the boundaries. In fact, approval from the Comics Code was becoming less and less of a necessity. Many comic books in the 1980s regularly appeared without the code's seal of approval.

For several years, Talbot produced work for the U.S. comic company DC. Two of the series he collaborated on made important contributions to the modern comic book era and the rising appreciation of the graphic novel.

Sandman

One of Talbot's important contributions to comics during this era began when DC Comics began to search for ways to expand its market. The idea was to publish sophisticated stories designed for mature readers. A

COMICS CULTURE AND SCIENCE-FICTION CULTURE

There has always been a connection between the realms of science-fiction culture and comic culture. The readers during the underground movement—mainly hippies—had a strong interest in science fiction as well. This was also true of comic-book fans and collectors. Early comics drew from the sci-fi fan movement, and early fanzines tended to focus on science-fiction content as well. Science-fiction bookshops and comic shops were often joint ventures.

Science fiction as a genre had been going through a renaissance period in the late 1960s and 1970s. The United States had accomplished putting a man on the moon in 1969, which ushered in a new optimistic period of space age science fiction and movies like *2001* and *Star Wars*.

This coincided with the rediscovery of fantasy as a subculture within science fiction, which was more closely related to fairy tales than usual science fiction, and often associated with the hippie interest in the works of J. R. R. Tolkien. Characters associated with this kind of genre were elves, wizards, and youths making quests to save something set in medieval surroundings.

Talbot took over the art for the "Song of Orpheus" story in Neil Gaiman's popular *Sandman* series. The chapter is a sort of "breather" between plot points in the series but pivotal because it covers the fate of the Sandman's son, Orpheus. One of the interesting things about the *Sandman* series is that Gaiman used many different artists to handle the interior art. Talbot's version of the character Sandman is especially haunting.

young British writer, Neil Gaiman, was commissioned to come up with a new fantasy series designed to appeal to these readers. Gaiman looked to a 1940s comic book hero, the Sandman, who had solved crimes by using sleeping gas. In the new *Sandman*, his powers came from the dream world itself, and Gaiman added a series of other supernatural characters that represented a diversity of human conditions. There was Dream, Death, Destruction, Destiny, Desire, Delirium, and Despair.

Sandman was an original creation, and the plot and characters evolved from the need to keep the story line flowing on a monthly basis. With the vast number of characters, almost all the traits of human nature could be explored. Because the series was about dreams, all of human history and mythology could also be explored. Historic figures such as William Shakespeare and Marco Polo became characters, as did Lucifer. The result of this mix was a series of complex, engaging stories that delighted adult readers.

A large part of the success of the series was the collaborative efforts of Gaiman and the artists who worked on it, including Bryan Talbot. Although the cover artist, Dave McKean, remained a constant, the interior work was given to a variety of artists, all with their own unique methods and styles. Instead of being confusing, this mix and match of styles pleased adult readers, with Gaiman writing different story lines to act in concert with the different skills and styles of the artists. Some stories were shadowy because a particular artist's style was shadowy. Others were lighter when the artist

emphasized lighter colors. Because there were specific story lines within the series, it became the habit for one artist or team of artists to illustrate one story within the series itself. This way, each individual story had a unique look.

The Sandman was a finite series running from 1988 until 1996. It enjoyed a steady popularity among readers during the first years of its creation. Its multiple story lines contained various cultural references and elements of the horror genre, and appealed to a wide cross-section of readers. In the 1990s, *The Sandman*'s success spread beyond the comics arena with excellent reviews of the series appearing in *Rolling Stone* and the *Nation*, two mainstream American publications. Riding on such success, DC Comics began to publish the comic in book form. The series received eight Eisner Awards, awards named after the comics creator Will Eisner that celebrate excellence in the comic-book field. The collected *Sandman* books were so successful as a series of graphic novels that they generated several other complete books that came about solely as concepts for graphic novels. A few of them are *The Sandman Companion, Sandman: The Dust Covers*, and *Sandman: King of Dreams*.

Sandman broke from the traditional comic-book formula in many ways and expanded nontraditional comic-book readership as well. Unlike most superhero monthly comics, the character Sandman did not appear on the cover. Instead, the covers reflected the book's ideas and the atmosphere of the stories. The series

breathed life into genre stories and showcased a number of extremely talented creators.

According to the official Bryan Talbot Web site, one of Talbot's contributions to this series, *The Sandman Special* number 1, "The Song of Orpheus," was also nominated for a Harvey Award, a comic industry honor.

Batman

Bryan Talbot also had a hand in the re-creation of another comic-book legend. DC Comics reintroduced a *Batman* story line that was familiar to readers, while at the same time largely reinvented. DC had stolen comics writer Frank Miller (who had previously worked on the comic *Daredevil*) from its rival, Marvel Comics, with plans to reinvigorate its *Batman* line.

Miller created a dark, deeply cynical version of *Batman* based on the new idea that Batman is psychologically compelled to fight crime. His story featured Batman at age fifty, after retiring from superhero status, reemerging to save Gotham City from his old enemy, the Joker. Robin has died, and at age fifty, Batman is no longer physically fit. Batman has to find a new Robin, and surprisingly, she is female. Batman and Robin do go on to save the day, but the story is more about survival than triumph.

For the first series, Miller was the artist as well as the writer. Purposely trying to disorient the reader, he experimented with the page breakdowns and deliberately kept the color dark. The series was packaged for adult readers, printed on expensive paper, and collected into one volume in 1987.

UNDERSTANDING COMICS AS AN ART FORM

According to Scott McCloud, in his *Understanding Comics*, a book done entirely in comic-book format that attempts to explain comic art as an aesthetic vehicle in its own right, comics can be defined as an art form that is sequential in nature. The definition does not attempt to qualify the subject matter, style, or quality of the work. The only qualification is that instead of one, two, or more pictures standing alone, the individual pictures are designed to follow each other.

Comics is different from other mass media, such as film or animation, in that animation is sequential in time, but not spatially juxtaposed, as comics are. Each successive frame of a movie uses the exact same space, a screen, while each frame for a comic must occupy a different space. So, "space does for comics what time does for film," according to McCloud.

Bryan Talbot later wrote and drew *MASK*, a two-part *Batman* story for *Legends of the Dark Knight*. It went on to be nominated for two Eisner Awards and was reprinted as *Dark Legends* in 1996.

This new *Batman* series was groundbreaking in that it was so cynical. The authors seem to warn that there is nothing out there that will protect you; you

have to defend yourself. They also suggest that super-heroes do not save people because it is the right thing to do, but because it's a psychological thrill for them to do so. To understand the subversive sense of this, one has to be familiar with the superhero construct of the past.

DC Comics was able to attract readership outside the main group of comic readers with this new dark version of Batman, and favorable articles were written in main-stream publications such as *Vanity Fair*, the *Los Angeles Times*, and *Rolling Stone*.

Independent Publishers and Collaborative Work

Besides his groundbreaking work for DC Comics, Talbot also produced work for independent publishers in the United States. The success of the more sophis-ticated comics geared to adult readers allowed these small publishing companies to flourish. Profits from a group of comic-book stores could support small staffs easily.

One such company, Dark Horse Comics, went on to publish several of Talbot's graphic novels (including *The Tale of One Bad Rat* and *Heart of Empire*). The company's founder, Mike Richardson, had owned a chain of successful comic-book stores before he delved into publishing comics in 1986. From the beginning, Dark Horse attracted some of the industry's best talent, including Bryan Talbot.

The Dark Horse Comics logo. Dark Horse is a successful publisher of comics, manga, and stationery products. It is the fourth largest comics publisher in the United States.

Talbot also produced work for other independents. For Cult Press, he created the cover art for the cyberpunk comic series *Raggedy Man*. For Tekno Comix he penciled the first six issues of *Teknophage*, written by Rick Veitch. He also wrote the six-issue miniseries *Shadowdeath*, which was illustrated by David Pugh.

Since the 1980s, Talbot has created comic strips for print publications that span genres, such as the *Manchester Flash*, *I.T.*, *Wired*, *Vogarth*, *Imagine*, *Knockabout*, and *Street Comics*. He has proved just as prolific with the creation of magazine illustrations, art prints, badges, and logos. Talbot has also done designs for British Aerospace and worked as a graphic designer for an advertising agency. For someone who had to teach himself practical art skills, Talbot certainly has learned how to make a living from art.

Talbot branched out into television in 1981, when he and science-fiction writer Bob Shaw collaborated on Granada TV Arts's program *Celebration*. The team produced *Encounter with a Madman*, directed by David Richardson. Over a decade later, in 1994, Talbot worked on a TV movie called *Above the World*. The movie was

Talbot has contributed this recent cover for the Italian comic *Winds of Winter*, written by Gianluca Pirreda and drawn by Stefano Cardoselli. What is different about this piece is that it is the first work that Talbot has created entirely on his computer. While digital art seems to be part of the future of comics, it is unlikely that comics creators will ever completely cast aside their pens and brushes.

an adaptation of a story by Ramsey Cambell, and Talbot produced the concept illustrations for it.

Talbot has held one-man comic art exhibitions in Lancashire, Tuscany, London, and New York City, and has appeared in numerous others. He is also a frequent guest at international comic festivals, appearing in front of crowds in Europe and the United States.

RETURN TO THE ADVENTURES OF LUTHER ARKWRIGHT

In the late 1980s, Talbot returned once more to *The Adventures of Luther Arkwright*. He completed the story in a sequence of nine issues that were then published as one volume. This was followed by a three-volume trade paperback version of the entire work, published by Dark Horse. The work is regarded as one of Talbot's most ambitious accomplishments, as well as being an extremely important part of the history of the graphic novel. It is generally assumed to be the first true British graphic novel.

Influences, Background, and Patronage for Arkwright

According to Roger Sabin's *Adult Comics*, Talbot was able to continue producing *The Adventures of*

Luther Arkwright because he was sponsored by the Frenchman Serge Boissevain, the publisher of *Pssst* magazine, almost, as Sabin writes, "in the fashion of a Renaissance artist by a rich patron."

Stylistically, the work is said to be influenced by the way movies are made, specifically the work of Nicolas Roeg, a British filmmaker whose films include *Walkabout* (1971), *Don't Look Now* (1973), and *The Man Who Fell to Earth* (1976). Roeg's signature style was a uniquely off-kilter view of the world, expressed through fragmented, dislocated images, yet with a strongly accessible approach to narrative. This can be seen in the way that the narrative jumps back and forth between times and places. Though difficult to follow in a traditional serialized form, *Arkwright* was magical in the longer and more involved form of a graphic novel.

Talbot states in *Adult Comics* that:

> It is true that I don't make many concessions to the reader. Because ultimately I think they are intelligent enough to work it out for themselves. Besides, they can always flick back through the pages to make sure they haven't misunderstood anything. It's all part of working on the larger scale.

The artwork itself is finely done, with no thought balloons or sound effects, unlike traditional Marvel or DC superhero comics. Unlike the endless and continuing sagas of most comic story lines, *Arkwright* is distinctive in that there is a definite beginning, middle, and end, with a satisfying, realized plot. The story concept begins with

This is a movie still from the 1976 film *The Man Who Fell to Earth*, directed by Nicolas Roeg and starring David Bowie. Bryan Talbot was heavily influenced by Roeg's work, and an examination of many of the Arkwright sequences reveals distinctive similarities. Note how this image of Bowie holding a gun bears a striking resemblance to Luther Arkwright himself.

the traditional good guys versus bad guys known as Disruptors. The main character, Luther Arkwright, undertakes profound changes in the course of the story. Not only does Arkwright change in terms of what he achieves and in the development of his abilities, but he also develops as a character, which is highly unusual for a comic-book creation.

COMICS AND GRAPHIC NOVELS NOW

*T*he graphic novel has truly grown up. Academic courses on comics and graphic novels as both art and literature can be found at universities throughout the country. The University of Mississippi Press actually has had its own publication featuring criticism on comics.

Outside of professional journals, in more mainstream publications, articles about comics and graphic novels appear in hip magazines and newspapers across the United States.

Since 2000, acceptance of the graphic novel has moved even more rapidly. Instead of being relegated to specialty and comic-book stores, graphic novels now command bookshelf space in chain bookstores. According to Stephen Weiner in his book *Faster than a Speeding Bullet: The Rise of the Graphic Novel*, one out of every five books sold in French bookstores is a graphic novel. In 2002, graphic novel sales in the United States increased by 23 percent, one of the only areas where book publishing grew.

The story itself is proof of Bryan Talbot's ability as a storyteller. As James Robertson, the creator of Talbot's official Web site, says in his review of *Arkwright*:

It must be said that you feel that this comic simply could not have been created in the

committee production lines that they call comic creation at Marvel . . . You are also utterly sure after reading this that this is a labor of love and that it took a storyteller at the height of his powers and an artist at the peak of his creativity in the same body to bring it off.

In his exhaustive explication of the forces and cultural background influencing the creation of Arkwright in his introduction to the Dark Horse version of the graphic novel, Michael Moorcock interprets the work as nothing less than literature. What he offers is a political theory. Britain, he says, was looking for a whole new future at the midpoint of the twentieth century. The country was trying to reinvent itself from the colonial European superpower it once was. During this time, other social upheavals were occurring. The Catholic/Protestant conflict in Ireland and the Falklands problem all occurred during the time when Talbot was creating Luther Arkwright. England's political ambitions and a sense of satire permeate the themes of Arkwright. "His quests are quests for alternatives, for a better way," Moorcock states.

Arkwright Summary

Talbot's story features parallel worlds, an idea familiar to science-fiction readers. Talbot's universe in *Arkwright* can be likened to that of a cut gemstone, with each parallel universe making up a facet of the whole stone, though each universe still remains separate and distinct. The most stable parallel is parallel 00.00.00, otherwise

known in the story as zero zero. In this dimension, the other parallels are discovered and eventually monitored by psychics who have the ability to reach their own alter-ego selves on other parallels of existence. It is from this vantage point that readers view the story.

The narrative stories that take place in *Arkwright* really exist in two parallels. One major narrative strand is the search for the entropy that has been slowly disintegrating the multiuniverse, and that search takes place on parallel zero zero. The people on zero zero see their enemy as a group the readers know only as the Disruptors, a mysterious force that owns the Firefrost Opal, which is causing the universe to fracture. To get this opal away from the Disruptors, the people inhabiting zero zero plan to create a revolution against a Disruptor-backed government on another parallel, forcing the Disruptors into conflict and revealing the opal. In the story, this is known as the Ragnarok strategy.

The separate parallel where the denizens of zero zero choose to enact this strategy is parallel 00.72.87, the location of the second narrative. A third, subtle narrative, weaves its way between the other two, holding them together and explaining the reasons behind everything. The narrative mix is quite complex, with images invading the traditional linear narrative of storytelling. There are flashbacks and flash-forwards, as well as flashes from other parallel worlds, which make the story seem chaotic, but which are actually precise and well-documented by Talbot. There are also scene changes from one comic panel to the next, as well as one-line

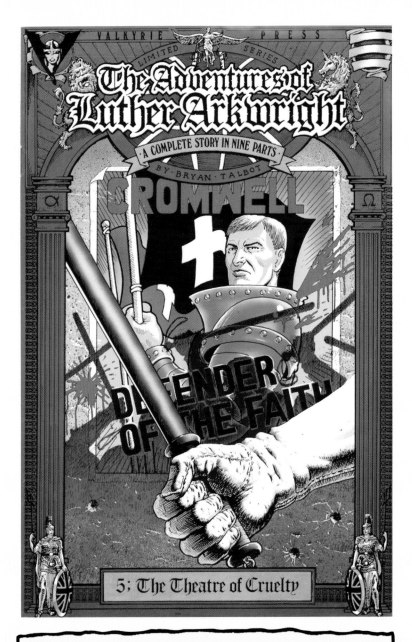

VALKYRIE PRESS

LIMITED SERIES

The Adventures of Luther Arkwright

· A COMPLETE STORY IN NINE PARTS ·

BY · BRYAN · TALBOT

CROMWELL

DEFENDER OF THE FAITH

5: The Theatre of Cruelty

The above cover is from the Valkyrie Press edition of *The Adventures of Luther Arkwright*, "The Theatre of Cruelty," distributed in England. Note the Oliver Cromwell propaganda poster in the background. In general, the British *Arkwright* covers reflect the issues' heavy political content much more than the U.S. covers, which tend to focus on Luther Arkwright in a superhero setting. It was assumed that American readers would respond to the action of Talbot's stories more than to his views on English history and politics.

news reports that run between the panels. In Robert Cave's *Luther Arkwright Thesis*, Talbot is quoted as saying, "Luther Arkwright came about as a reaction against Marvel Comics . . . a reaction against the mainstream . . . [it was] very self-consciously experimental."

Beyond the experimental narrative structure, the plot of the story contains two basic ideas. One is the idea of imperial nationalism that overarches everything, and the other is that of class struggle and warfare. Arkwright is highly patriotic. The character of Octobriana, a female Russian freedom fighter, has a name that suggests the Russian October Revolution (1917).

Talbot is also trying to make a political statement with the parallel 00.72.87, where the revolution takes place. On this parallel, among other things, the British Restoration movement (1660–1668) never occurred, and England is ruled by the descendants of Oliver Cromwell, in a kind of anti-monarchy. England's flag is a symbol for terrorism on this parallel. Talbot uses this symbol deliberately, drawing a reference to the Northern Ireland conflict in our own world in a kind of turnabout satire.

According to Cave, one of the striking things about *Arkwright* is how British the story is—perhaps making it somewhat more difficult (although not irrelevant) for Americans to understand. The story is ambitious in itself, but at the same time, the drawings are very highly skilled. What Talbot chose to do in *Arkwright* is different from what anyone else had ever attempted to do before him. He was not only trying to describe and comment on

what was going on in England in the present, but he was also putting a mirror up to the larger world as a whole. And all of this was offered through an alternative view of the history of modern times and the British Empire, a "what if" analogy that turned everything on its head.

The character of Luther Arkwright is unmistakably British and is taken from real-life historical figure Richard Arkwright who invented the water frame that was used in cotton mills, one of the many new technologies upon which the British Empire was built. He was also the father of the modern factory system created during the Industrial Revolution (beginning in the eighteenth century). Arkwright's narrative begins in the Heart of Empire on parallel 00.38.56, where the reader is led to believe that the British Empire still survives. Arkwright is tall, blond, strong, and clad in full imperial British finery. He has been compared to another gorgeous but equally fictional character people think of when they think about Britain—James Bond. So it doesn't seem unnatural for *Arkwright*'s narrative to unfold with a short action sequence, after which he encounters a beautiful naked woman, and then quickly reappears as an agent of Her Majesty, for a briefing on his mission.

However, the imperial British grand narrative is not suggested as something that is in any way positive. Despite the British theme throughout the text, the people on the various parallels seem happy to exploit each other. This ambivalence can be read thematically as arrogance and an ideology of exploitation of the citizens of one's own country.

This page from *Luther Arkwright* shows Luther visiting the tomb of Karl Marx. He draws the tarot card for destiny, and he has an epiphany. "Like Marx I realized I was a son of Destiny—a catalyst predestined to affect world history. I was brother to Alexander the Great, Napoleon, Christ, Attila, Gautama Bhudda, Mao, Lincoln, Churchill, and all the other slaves of fate." Talbot's art style reflects the sophisticated content of the Arkwright story. Note the eerie tone and the absence of thought and dialogue balloons.

In parallel 00.72.87, the character of Arkwright has at least three lovers. The life of one of these, Princess Anne, and of Luther's unborn children, hang on the success of the Royalist revolution against the Cromwell Empire. Throughout the text, it is never clear whether Arkwright ever takes fatherhood as a serious responsibility, or if he has bastard children throughout the various universes.

Although Arkwright is helping the Royalists against what is also a repressive regime, the Royalists are not completely good either. They live among violence and sexual excess that the Puritans despise. Their culture is depicted as disease ridden and mentally unhealthy; the future queen, Anne, is quite willing to kill her own brother so that she can become the leader of a strong monarchy. After the Royalists eventually win the civil war on 00.72.87, the faults of this society are made even clearer, with violence inflicted upon fallen enemies, and with the Royalists destroying Puritan literature, similar to the Nazi's book burnings. The nonglorification of violence is rare and very unlike what is found in mainstream comics.

The final plot line involves a race of godlike beings that created the Firefrost Opal. Here there is the creation of an all-powerful Firefrost used as a deterrent until, in a direct correlation to government policy concerning nuclear war in our world, the device is activated, killing almost everyone.

Luther Arkwright's Impact

The Adventures of Luther Arkwright has been so influential and has garnered such a solid fan base that

ATTENDING A COMICON

Comicons, otherwise known as comic-book conventions, are often overwhelming events full of selling and trading comic books, pizza, celebrity creators, and fans—lots of fans. Fans get to meet and mingle with each other and also with comic industry professionals. Comicon regulars get to greet old and new friends.

At most comic-book conventions, the dealers' room is centrally located, with the dealers selling a variety of items, including comic books, old paperback books, action figures, T-shirts, and videotapes. Most of the dealers are comic-book shop owners hoping to sell some of their stock. They also sell collectibles, games, and other items dealing with a variety of comics.

Buying and selling takes place outside the dealers' room as well. Large comicons also devote spaces to comic publishers, with many of them using video displays and music to sell their products. Free merchandise is also available, and it is not unusual for a comicon attendee to come home with dozens of posters.

several fan-based Web sites have been created in its honor, as well as a role-playing game and a future feature film. *Arkwright* has been studied in the academic realm, too, with research and academic theses written on the work as a serious piece of literature and art.

In the original *Luther Arkwright* role-playing game, players take on the parts of men and women living on

one of the myriad alternate Earths coexisting within our own. These Earths are in many ways like our own yet different, especially in political geography, historical evolution, and technological advancement. An example is an Earth where the United States is an enlightened nonindustrial country that keeps to itself, while the British Empire survives into our times as a totalitarian regime under the rule of an empress. You can get more information on the game on Bryan-Talbot.com.

In addition, KouKou Productions, a Melbourne, Australia-based film production company, has announced plans to develop *The Adventures of Luther Arkwright* into a feature film. Melbourne-based comic-book writer and artist Bruce Mutard has been commissioned to write the screenplay. KouKou Productions hopes that production of *Luther Arkwright* will begin in 2005. It has also bought a three-year option to make a film of *Heart of Empire*, Talbot's sequel to *Arkwright*.

ONE BAD RAT AND ONWARD . . .

First published in 1995, Bryan Talbot's *The Tale of One Bad Rat* is the second-most requested graphic novel in U.S. libraries. A moving tale of a teenage runaway trying to escape child abuse, it is the recipient of numerous awards, including an Eisner Award, a Comic Creators Guild Award, two UK Comic Art awards, two U.S. Comics Buyer's Guide Don Thompson Awards, and the Internet Comic Award for Best Graphic Novel.

Popular not only in English-speaking countries, it also won a Haxtur Award in Spain, an Unghunden Award in Sweden, and a Bédélys Découverte Award in Canada. And the list goes on, with nominations for a British Library Award, the National Cartoonists' Society of America's Rueben Award, a Harvey Award, and inclusion on the *New York Times*'s annual recommended reading list.

The book's success was spurred not only by Talbot's recognized talent and stature within the comic industry, but also because of its groundbreaking subject matter and sensitive execution, which appealed to a broad spectrum of readers.

Talbot says he never intended to create a comic book about child sexual abuse, but that the theme evolved out of an interest in doing a story about the Lake District in England. In an interview with Michael Gilman for Dark Horse Comics, Talbot says that the Lake District "is an amazing place. I've been in love with it for most of my life. There are a lot of different angles I could've gone on, but I started looking at Beatrix Potter, a very famous children's writer—probably better known in Britain than Walt Disney."

When he remembered seeing a young homeless girl a few years before in the Tottenham Court Road tube (subway) station, something clicked creatively. Beatrix Potter had had an oppressed childhood and was described as being painfully shy. The girl in the tube station also seemed extremely shy, and as Talbot remembered, was being harassed by a religious advocate who had been trying to persuade her to go somewhere with him.

Talbot states, "Very often stories take on a life of their own, and that's certainly true of *One Bad Rat*. The child-abuse angle came in because when I was plotting it out I thought, 'Why did she leave home?' And I thought, 'Well, her father's been abusing her,'" which is a common enough reason for kids leaving home. It

seemed to make sense. I just packed it in there and didn't think much of it."

Talbot spent a great deal of time researching the story. He read books about Beatrix Potter, books about the Lake District, and several on the sexual abuse of children. He also spoke to a few victims of child abuse themselves. And as his research progressed, he decided that he could not use the sexual abuse theme as just a plot device; it had to be the main reason for the story. "It took over as the theme to the story—what began as a book about the Lake District became a book about the aftereffects of child sexual abuse," he told Gilman.

But the story is also filled with references to Beatrix Potter, although familiarity with Potter and her work isn't necessary for understanding the story. As a nod to Potter, each character in *One Bad Rat* is named after a character from one of Potter's stories.

It has been theorized that the famous children's book author was also an abused child herself, though in Victorian England, things like child sexual abuse were never mentioned. It is known that Potter was basically kept as a prisoner in her family's London house, and that she had very little contact with other children. Even her brother, Bertram, was sent away to school when he was six years old. Potter never had many friends, apart from the animals she smuggled into the house.

To summarize, the story of *One Bad Rat* is about a girl who runs away from home to escape sexual abuse from her father and psychological abuse from her mother. She takes to the streets of London accompanied

BEATRIX POTTER

One of Bryan Talbot's inspirations in writing his graphic novel, *The Tale of One Bad Rat*, was the well-known British illustrator and storyteller Beatrix Potter. In the epilogue of *One Bad Rat*, Talbot writes that she "was an expert at telling stories using a combination of words and pictures—there was a correlation with comic art." But he says, though he was not interested in doing a biography of Potter, he was struck by her story after visiting the English Lake District and wanted to use it as a jump-off point.

But Potter was interesting in her own right. Best known as the creator of beloved characters such as Peter Rabbit, she was also an accomplished botanical illustrator, a sheep breeder, and a conservationist who was dedicated to her home, the Lake District of England.

She was born in 1866 to a wealthy Victorian family, and also had a brother named Bertram. She was homeschooled by governesses and was known to be an exceedingly shy child. Her family vacationed at the Lake District during summers, and it was there that she met a man named Hardwicke Rawnsley, a writer and also the vicar of Wray. He was a large influence on Potter throughout her life. It was he who encouraged her painting and interest in animals.

The *Tale of One Bad Rat* is a startlingly realistic story that uses a very unrealistic character—a giant rat—as a device to show an abused girl's pain and desperate need to have an ally and confidante. The panel at the top shows runaway Helen sitting at a diner booth with her pet rat, who grows to human-size when Helen feels most alone. The two lower panels show a flashback sequence, when Helen remembers an instance when her father abused her and she had the strength to fight back.

by her pet rat, and moves on to England's Lake District, where she finds redemption through the kindness of an adoptive family. Some readers of *One Bad Rat* see the character of Helen, the runaway girl, as a reincarnation of Beatrix Potter. However, this was not Talbot's intention. Instead, as he told Gilman, he "wanted to give the impression of two lives touching each other across the years, and how this unspoken connection with Beatrix Potter eventually leads Helen to overcome her psychological restraints."

The rat itself is a very important character in the story. Helen's mother is the first to call Helen a bad rat in the narrative. At one point, when Helen is running away, Helen scratches her father's face, and he also calls her "a vicious little rat." The rat is used as a symbol of Helen's alienation and self-hatred, but it also becomes a symbol of her ability to survive. Another link to Talbot's theme is that Beatrix Potter herself also had a pet rat.

Talbot told Gilman, "As far as the title, it just seemed natural. Also, for the purpose of telling an entertaining story, the rat was a great storytelling device. It meant that I didn't have to have a single thought balloon in the whole book. Helen could speak any of her thoughts directly to the rat." It was Talbot's main intention simply to produce a good comic story that would appeal to a wide audience. "I think that part of the enjoyment people will get from reading the story will be simply being in the company of Helen," he said, "not just this ray of hope concept [regarding child abuse]." However, as he told Gilman, he does have hope

that his work can shed light on the problem of child sexual abuse:

> What it may achieve is an awareness. A lot of the victims of child sexual abuse—the younger victims especially—think this is only happening to them. They think that they're totally isolated and on their own. They can't tell anybody, because they won't believe it's happening . . . Obviously, the more child abuse is discussed in society and fiction—movies, comics, and text fiction—the more stories, the more people realize that this is happening all the time.

So, the more people are aware of the problem, the more victims realize it's not just something that's happening to them alone. *One Bad Rat* has become a very beneficial tool for use in child abuse centers both in England and the United States. It is accessible to many readers, and when shown the comic, it is easier for victims who find it hard to express their own feelings to identify with the character of Helen, and then to talk about her experiences and pain, rather than their own feelings directly.

Artistically, *One Bad Rat* also has greater appeal for a wider audience than most mainstream comics, or even the works of the underground period. Talbot says that he tried to take "a lot of things out that people who don't usually read comics may think of as being childish in some way." Thought balloons were the first to go, as were sound effects. There are no sound effects throughout the entire book.

This panel from the climactic scene of *One Bad Rat* shows Helen in a violent storm, unleashing her anger and letting go of her pain. Talbot did extensive research on the Lake District area so his scenery would be especially accurate and realistic. He also used live models for his drawings, which lends to the realism and poignancy of the work.

The Tale of One Bad Rat is truly one of the most successful and appealing graphic novels to date. Recently, a film company, Fat Dragon Productions, acquired the rights to the story for an upcoming feature film. Also, as Talbot told Gilman, "It's amazing the number of people in the industry who have shown *Bad Rat* to someone who doesn't usually read comics, and has come back to me with a really good response." For example, he says, an industry insider at the company Tekno Comix gave it to his grandmother to read, "and she's probably never read a comic in her life, but she loved it."

Heart of Empire

Bryan Talbot's newest graphic novel, *Heart of Empire*, was published in 1999 in a nine-part series by Dark Horse Comics. It has won an Eagle Award and was also nominated for the Eisner Awards. Three years in the making, *Heart of Empire* is something of a sequel to *The Adventures of Luther Arkwright*.

Set twenty-three years after the original *Arkwright* story, this new story features as its main character Victoria Mary Elizabeth Boudicca Miranda Cordelia Arkwright Stuart, the Crown Princess of the Glorious British Empire, and Luther Arkwright's daughter. She is a nearly seven feet tall, skinny, white-haired, twenty-two-year-old woman with psychic powers.

Victoria's parallel world, her England, is one where the Cromwell Regime dominated into the late twentieth

century. Her father, Arkwright, helped to destabilize that regime in *The Adventures of Luther Arkwright*. What Victoria knows as stability and a golden age for the Royalists is actually built on violence and atrocity.

A reviewer for the online magazine *Ozymandias* stated that it was interesting for Talbot to "make [his] superhuman protagonist a cranky [woman], and doing so helps make abundantly clear the fascism that lurks close to the surface of the Empire, through the unselfconscious way this ultimately well-intentioned product of royal privilege exploits and abuses everyone around her."

This is the cover of the first issue of *Heart of Empire*. Although it is about Luther Arkwright's daughter, *Heart of Empire* does not carry on the style and tone of *Arkwright*. The art is clearer and more colorful, and the story is warmer and more character-driven.

Victoria's father is absent from this work until the end of the sixth issue, and when he does appear, he is very much a changed character from the original *Arkwright* novel. In this new work, instead of being a powerful superhuman, Luther has renounced violence and become almost monklike, detaching himself from the parallel world full of violence and unease. *Heart of Empire* focuses much more on the character of Victoria, but this is still an *Arkwright* universe in the tradition of stories filled with political satire. Princess Diana appears as a character in the story, as do renowned British artist Damien Hirst and Prime Minister Tony Blair. Trans-universal psychic warfare, destruction of planet-sized supercomputers, and sarcastic arguments over proper language usage also fill the pages.

Artistically, Talbot also made some changes from *The Adventures of Luther Arkwright*. The art is in color, cleaner and sparser, closer in style to that of *The Tale of One Bad Rat*. Angus McKie, the colorist who worked with Talbot on the art for this graphic novel, creates some stunning visual effects featuring adjusted backgrounds of London and Rome, designed to fit the parallel universes Talbot has created.

In the online magazine PopImage, Arni Gunnarsson writes, "Indeed, there are plenty of pages that would stand alone as works of art . . . the characters are always well-rendered, the expressive close-ups amazing." One of Talbot's own observations about modern comic-book art is that the body language of characters is often poorly represented. In this story, however, the

IMPERIAL PALACE GARDENS

This panel shows Luther Arkwright's daughter, Victoria Mary Elizabeth Boudicca Miranda Cordelia Arkwright Stuart, the heroine of Bryan Talbot's *Heart of Empire*. For this series, Talbot researched history, costumes, buildings, language, and the city of London itself.

WOMEN AND COMICS

*T*he very first adult comics produced in the 1800s set the tone for the majority of modern comics. They were produced by men for a mostly male audience. Most were meant to be humorous, and some, reflecting the attitude of the age, were flatly used as pin-ups of popular music hall starlets.

Yet, even in the early stages, women were recognized as a legitimate audience for comics. There were even one or two female creators during the *Ally Sloper* era in Britain. One was Emily de Tessier, who went by the name Marie Duval. She was the wife of the Sloper character's creator, Charles Ross.

During the children's era of comics, the industry was basically dominated by men, although the female market was not ignored. Adventure comics were not welcoming for girls, so a new kind of specialty comic featuring boarding-school tales and romances was created.

The underground movement saw a breakthrough for women in comics. Female creators were active and were creating their own works. Works such as *It Ain't Me, Babe*; *Heroine*; and *Wimmen's Comix* were popular.

In the present day, alternative publishers are active in the publishing of comics for and about women, although comics in general still have a mostly male audience.

characters grimace with pain, and the costumes are well-researched and detailed.

Talbot's storytelling talents have also become more honed. *Heart of Empire* has a more straightforward narrative and is easier for the reader to grasp. Gunnarsson continues:

> As the story develops, the reader is drawn deeper into this fantastic world. Talbot has combined elements from various cultures and eras in human history. A combination of opulence, splendor, humor . . . Fear, racism, conquest . . . and ultimately salvation make *Heart of Empire* [great].

Heart of Empire CD-ROM

According to James Robertson, the Web site editor and creator of the Official Bryan Talbot Fan Page, "When Bryan completed *Heart of Empire*, he started to get asked a lot of times: 'Where do you get your ideas from?' One time he mentioned this to me. I suggested we create a CD-ROM that answered all those questions." Thus, the idea for the *Heart of Empire* CD-ROM was created.

On the CD-ROM, which is available for purchase on the Web site, Talbot annotated the text of the graphic novel, explaining references and allusions, symbolism, and the inside jokes that underlie the narrative of the story. There is information on the artwork and essays on subjects that are relevant to the story. The entire

graphic novel is also available on the CD-ROM, in the penciled, inked, and colored forms.

The CD-ROM is a treat for fans, designed by a fan himself. It also includes great extras such as interviews and biographies. It's a behind-the-scenes look into all that goes into the creation of a graphic novel, in which Talbot, as the press release for the CD-ROM states, "Gives all the secrets away!"

Looking Ahead

For more than twenty years, Bryan Talbot has been producing some of the best comic art and narrative stories available in any country. His contributions to the underground and mainstream worlds of comics and graphic novels cannot be denied. Starting with underground comics such as *Brainstorm*; followed by his groundbreaking work with *The Adventures of Luther Arkwright*; his work with the experimental *2000 AD*; his work with the mainstream American DC Comics producing titles such as *Hellblazer*, *The Nazz*, *Fables*, and *Sandman*; to his graphic novels that he wrote and illustrated, including *Batman*, *The Adventures of Luther Arkwright*, *The Tale of One Bad Rat*, and *Heart of Empire*, Talbot has had a prolific and well-rounded career.

He has won many awards within the industry, as well as outside it. He has been a frequent guest at comic-book conventions, or comicons, as well as at literature festivals. His illustrative work has been displayed in

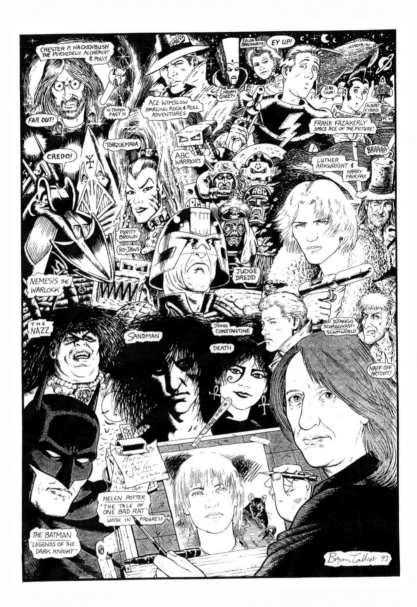

This 1993 montage shows many of the characters Talbot has created or drawn in the span of his career, from Chester P. Hackenbush to Luther Arkwright to Talbot's version of Neil Gaiman's Sandman to Helen Potter from *One Bad Rat* (at the time a "work in progress"). Talbot has sketched himself working at his drawing board, in the company of his beloved characters. The piece is a quick reference to Talbot's work, and it is a simple reminder of his vast influence on the comics genre.

BRYAN TALBOT TIMELINE

1952 Bryan Talbot is born in Wigan, Lancashire, England, on February 24.

1969 Talbot's first published illustrations appear in the British *Tolkien Society* magazine.

1972 Talbot creates a weekly comic strip for his college newspaper along with friend and fellow cartoonist Bonk.

1975 Talbot starts the *Brainstorm Comix* series, featuring the character of Chester P. Hackenbush.

1978 Talbot begins *Frank Fazakerly, Space Ace of the Future*, and also the first official British graphic novel, *The Adventures of Luther Arkwright*.

1982 *Luther Arkwright* is published by Never Ltd. in one collected volume, the first graphic novel in Britain. It wins numerous awards.

1983 Talbot begins working for *2000 AD*.

1995 Talbot publishes *The Tale of One Bad Rat*, which wins numerous awards.

1999 Talbot publishes *Heart of Empire*, the sequel to the earlier *Luther Arkwright* story.

1999 The Bryan Talbot *Heart of Empire* official CD-ROM is released on April 14.

one-man and group shows throughout the world. In particular, his *Luther Arkwright*, the first true British graphic novel, and his breakthrough success, *The Tale of One Bad Rat*, have contributed to the genre of the graphic novel.

As Paul Dawson, an academic in Britain, and the first to offer a college course that examines graphic novels as a new art form, states in Roger Sabin's *Adult Comics*:

> We have hardly begun to sketch out an aesthetic appropriate to the [comics] form . . . the assimilation of comics to the novel is tempting, because it offers a way to domesticate a form which we are still struggling to understand adequately.

The popularization of the form starting with the mid-1980s to the present day has led to the recognition of comics by the literary establishment, with mainstream book publishers and some comics publishers. Graphic novels are also beginning to be reviewed in the literary pages of the popular press, both a good and a not-so-good development for the form. Not-so-good because it signals a trend of co-option of a comics culture into a book culture, with illustrated novels reviewed as straight books and the writers profiled and held in higher esteem than the artists.

Another disappointment is that the 1990s commercial failure of the genre was so pronounced that some booksellers were pulling them off their shelves, with certain publishers deciding against marketing them

altogether. Media criticism was the result, with head-lines like, "Biff, Bang, Krapp! If adult comics are the wave of the future, how come nobody's reading them?" as reported in Roger Sabin's *Adult Comics*.

Nonetheless, graphic novels are here to stay. They exist as their own identifiable category and art form, with a history, a present day, and a future. Though they have not necessarily generated the commercial success that would make them as mainstream as industry insid-ers would like, they do exist as an established and exciting form that has found its place in mainstream popular culture.

As for Bryan Talbot, he is still creating. One of his latest projects includes a graphic novel, titled *Alice in Sunderland*, a 250-page story done in black and white with spot color. The theme for the comic is *Alice in Wonderland*'s author, Lewis Carroll, and his muse, Alice Liddell. It is told in "a dream-logic documentary style," Talbot says in an interview on his official Web site. "But the book is really about history and storytelling and contains many other stories running the gamut of styles, all intricately woven." So far, the project does not have a publisher, but one is being sought.

When he is not creating, Talbot is also very active with comics festivals and conventions in Britain and abroad. He also tours and lectures at universities and arts schools around the world.

Bryan Talbot's decades of quality work have clearly established him as a genius in his field. Although he is most likely too modest to admit it,

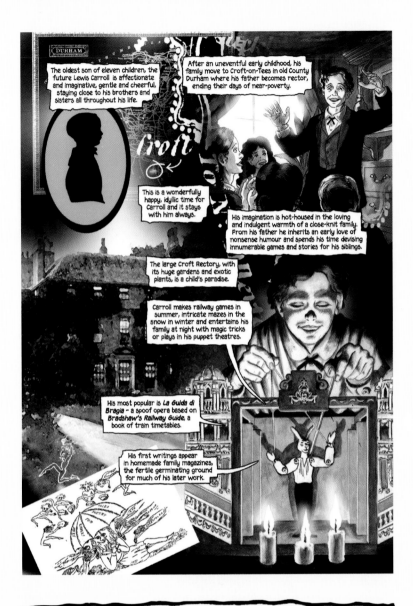

The oldest son of eleven children, the future Lewis Carroll is affectionate and imaginative, gentle and cheerful, staying close to his brothers and sisters all throughout his life.

After an uneventful early childhood, his family move to Croft-on-Tees in old County Durham where his father becomes rector, ending their days of near-poverty.

This is a wonderfully happy, idyllic time for Carroll and it stays with him always.

His imagination is hot-housed in the loving and indulgent warmth of a close-knit family. From his father he inherits an early love of nonsense humour and spends his time devising innumerable games and stories for his siblings.

The large Croft Rectory, with its huge gardens and exotic plants, is a child's paradise.

Carroll makes railway games in summer, intricate mazes in the snow in winter and entertains his family at night with magic tricks or plays in his puppet theatres.

His most popular is *La Guida di Bragia* - a spoof opera based on *Bradshaw's Railway Guide*, a book of train timetables.

His first writings appear in homemade family magazines, the fertile germinating ground for much of his later work.

DURHAM

Croft

This is a page from Bryan Talbot's new graphic novel, *Alice in Sunderland*. A 250-page book due for a 2005 publication, the work first will be serialized in the magazine Words and Pictures. *Alice in Sunderland*, a black and white with spot color story that uses *Alice in Wonderland* author Lewis Carroll and his muse Alice as jumping-off points to examine themes such as history and storytelling, is different from anything Talbot has done before. This page shows the documentary-like approach Talbot uses to bring the reader into Carroll's story.

Bryan Talbot is considered to be the godfather of modern British comics. His work has been pivotal to the development of comics and has shown real importance and substance as it bridged the underground movement of the early 1970s to the beginning of the modern era at that decade's end. His successes and the promise of continuing that success have given the genre the hope it needs.

The End

SELECTED WORKS

The Adventures of Luther Arkwright. Milwaukie, OR: Dark Horse Comics, 2003.

Batman: Dark Legends. Bryan Talbot, et al. New York: DC Comics, 1996.

Heart of Empire. Milwaukie, OR: Dark Horse Comics, 2001.

Sandman: Fables and Reflections. Written by Neil Gaiman, illustrated by Bryan Talbot, et al. New York: DC Comics, 1993.

The Tale of One Bad Rat. Milwaukie, OR: Dark Horse Comics, 1995.

Comic Creators' Guild Award
The Tale of One Bad Rat

Eagle Award
Best Artist (*The Adventures of Luther Arkwright*, 1988)
Best Character (*Nemesis the Warlock*, 1983;
The Adventures of Luther Arkwright, 1988)
Best Comic Cover (*The Adventures of Luther
Arkwright*, 1988)
Best Graphic Novel (*Nemesis the Warlock*, 1983)
Best New Comic (*The Adventures of Luther
Arkwright*, 1988)
The Tale of One Bad Rat

Eisner Award
Best Graphic Album: Reprint (*The Tale of One Bad
Rat*, 1996)

Mekon Award
Best British Work (*The Adventures of Luther
Arkwright*, 1989)

UK Comic Art Awards
The Tale of One Bad Rat

U.S. Comics Buyers' Guide Don Thompson Awards
The Tale of One Bad Rat

GLOSSARY

caricature Art that distorts or exaggerates characteristics in order to expose the absurdity of a person or situation.

comicon Slang for a comics convention.

fanzines Amateur magazines published by and for comics fans.

graphic novel Term used to describe a long narrative told via sequential art panels.

head shop A shop specializing in articles of interest to drug users, prevalent in the 1960s and 1970s.

lithography The process of printing with ink and a flat surface, which allows multiple copies of a piece of art to be reproduced.

patriarchy A system of government or society that is ruled by men.

pulp Poor quality writing often printed on cheap paper.

satire A humor form that uses ridicule, irony, and sarcasm to make fun of a person, usually a public figure or politician.

science fiction Fiction that uses as a theme the impact of real or imagined science on a society.

serial Work published or produced in installments.

underground comics Adult-oriented comics published outside the commercial comics industry.

vestige A trace, mark, or visible sign left by something (such as an ancient city, condition, or practice) vanished or lost.

FOR MORE INFORMATION

Comics Magazine Association of America (CMAA)
355 Lexington Avenue, 17th Floor
New York, NY 10017-6603
(212) 661-4261

ComicsResearch.org
Gene Kannenberg Jr., Assistant Professor of English
University of Houston
One Main Street
Houston, TX 77002
(713) 221-8000

MOCCA
Museum of Comic and Cartoon Art
549 Broadway, Suite 401
New York, NY 10012
(212) 254-3511
Web site: http://www.moccany.com

New York City Comic Book Museum
P.O. Box 230676
New York, NY 10023
(212) 712-9454

Words and Pictures Museum
140 Main Street
Northampton, MA 01060
(413) 586-8545
Web site: http://www.wordsandpictures.org

Web Sites

Due to the changing nature of Internet links, the Rosen Publishing Group, Inc., has developed an online list of Web sites related to the subject of this book. This site is updated regularly. Please use this link to access the list:

http://www.rosenlinks.com/lgn/brta

FOR FURTHER READING

McCloud, Scott. *Understanding Comics*. Amherst, MA: Kitchen Sink Press, 1993.

Sabin, Roger. *Adult Comics: An Introduction*. New York: Routledge, 1993.

Sabin, Roger. *Comics, Comix and Graphic Novels: A History of Comic Art*. New York: Phaidon Press, 2001.

Weiner, Stephen. *Faster Than a Speeding Bullet: The Rise of the Graphic Novel*. New York: Natier-Beall-Minoustchine Publishing, Inc., 2003

Weiner, Stephen. *The 101 Best Graphic Novels*. New York: Natier-Beall-Minoustchine Publishing, Inc., 2001.

BIBLIOGRAPHY

Anderson, John. "An Interview with Bryan Talbot."
Mars Import. Retrieved February 8, 2004
(http://www.marsimport.com/feature.php?ID=
2&type=1).

Brown, Rachel Manija. "Bryan Talbot, The Tale of
One Bad Rat." Retrieved February 8, 2004
(http://www.greenmanreview.com/book/
book_talbot_onebadrat.html).

"Bryan Talbot." Retrieved December 31, 2003
(http://www.lambiek.com/talbot_bryan.htm).

"Bryan Talbot: From Brainstorm to Bad Rat." Retrieved
January 7, 2004 (www.hairy1.demon.co.uk/psfg/
bryan2.htm).

Cave, Robert. "The Arkwright Thesis." Retrieved April
22, 2004 (http://www.bryan-talbot.com).

Creator Profile: Bryan Talbot: Artbomb.net. Retrieved
February 2, 2004 (http://www.artbomb.net/
profile.jsp?idx=6&cid=155).

"Driving Bryan Talbot." Retrieved February 7, 2004
(http://www.boreders.com/events.php?article=talb).

Durham Literature Festival 2002: Bryan Talbot.
Retrieved February 1, 2004
(http://www.cornwell.nu/litfest/2002.html).

Ellis, Warren. "*Heart of Empire* Review." Retrieved
April 22, 2004 (http://www.bryan-talbot.com).

Gilman, Michael. Darkhorse Interview with Bryan Talbot. The Official Bryan Talbot Home Page. Retrieved February 1, 2004 (http://www.bryan-talbot.com).

Groth, Gary and Robert Fiore, ed. *The New Comics*. New York: Berkley Books, 1988.

Gunnarsson, Arni. "*Heart of Empire* Review." Popimage: The Official Bryan Talbot Home Page. Retrieved February 1, 2004 (http://www.bryan-talbot.com).

"*Heart of Darkness.*" Retrieved February 4, 2004 (http://www.sfsite.com/columns/scott104.htm).

"*Heart of Empire Review,* Ozymandias." The Official Bryan Talbot Home Page. Retrieved February 1, 2004 (http://www.bryan-talbot.com).

"Luther Arkwright." Retrieved February 2, 2004 (http://www.modernvikings.com/luther-arkwright/).

McCloud, Scott. *Understanding Comics*. Amherst, MA: Kitchen Sink Press, 1993.

The Official Bryan Talbot Fan Page. Retrieved December 30, 2003 (http://www.bryan-talbot.com).

The Podium Interview with Bryan Talbot. Retrieved January 7, 2004 (http://www.members.aol.com/PODIUM1/talbot.html).

Pustz, Matthew J. *Comic Book Culture*. Jackson, MS: University Press of Mississippi: 1999.

Roberts, Sidra. "An Interview With Bryan Talbot." Coville's Clubhouse. Retrieved February 2, 2004 (http://www.collectortimes.com/2002_01/Clubhouse.html).

Sabin, Roger. *Adult Comics: An Introduction*. New York: Routledge, 1993.

Sabin, Roger. *Comics, Comix and Graphic Novels*. New York: Phaidon Press Inc., 2001.

Sabin, Roger. "*Introduction to the Brainstorm*" Reprint. Retrieved February 11, 2004 (http://www.bryan-talbot.com).

Straw, Deborah. "More than Just Bunnies: The Legacy of Beatrix Potter." The Literary Traveler. Retrieved February 14, 2004 (http://www.literarytraveler.com).

Talbot, Bryan. *The Adventures of Luther Arkwright*. Milwaukie, OR: Dark Horse Comics, Inc., 1997.

Talbot, Bryan. *The Tale of One Bad Rat*. Milwaukie, OR: Dark Horse Comics, Inc., 1995.

Weiner, Stephen. *Faster than a Speeding Bullet: The Rise of the Graphic Novel*. New York: Natier-Beall-Minoustchine Publishing, Inc., 2003.

INDEX

About the Author

Lita Sorensen is an artist and writer living in Iowa City, Iowa.

Credits

Cover, pp. 4–5 © Bryan Talbot; cover (comics panels), title page, pp. 3, 33, 36, 46, 51, 65, 73, 76, 84, 87, 89, 91, 95, 99 © DREDD: Rebellion UK; p. 12 Library of Congress Prints and Photographs Division; pp. 17, 18 Copyright © 1999, The British Library Board; p. 25 © Hulton/Archive/Getty Images; p. 27 © Roger Ressmeyer/Corbis; p. 40 2000 AD and Judge Dredd © Rebellion A/S 2004 (www.2000adonline.com); p. 44 (left) Courtesy Jackie Estrada; p. 44 (right) Courtesy Sue Grant; p. 64 Dark Horse Comics ® & the Dark Horse logo are registered trademarks of Dark Horse Comics, Inc.; p. 69 Copyright © Courtesy Everett Collection/Everett Collection

Many thanks to Bryan Talbot for his assistance in providing imagery for this book.

Designer: Les Kanturek